PENGUIN BOOKS

WEARABLE ART

Maria da Conceição (São) was born in Evora, Portugal, where her interest in fiber arts was piqued at an early age. In 1964 she decided to pursue her studies in Denmark, and shortly thereafter she began to work professionally for the Danish Handcraft Guild until 1971. She moved on to Nairobi, Kenya, and continued to design until 1974, the year she settled in Washington, D.C. Since her arrival in the United States she has been working as a full-time artist-designer, making wearable art, wall hangings, and soft sculpture, which have been exhibited in more than twenty single and group shows of her work, most recently at the Textile Museum in Washington. In 1976 the National Cathedral, in Washington, D.C., engaged her to design a chasuble and two complementary vestments, which were then featured in the 1978 Vatican Museum exhibition, "Craft Art and Religion of America." Her lectures and classes on wearable art and wall-hanging techniques at the Smithsonian Institution and the Renwick Gallery have encouraged many women (and men) to think more creatively about their clothes.

Nancy Grubb is currently a writer-editor for the Hirshhorn Museum and Sculpture Garden in Washington, D.C. From 1971 to 1978 she worked at the Los Angeles County Museum of Art. All in all, she has worked on more than thirty books. In addition to her editing and writing skills, she is quite accomplished with a needle—embroidery, crochet, and needlepoint are only three of her interests.

A professional photographer for more than fifteen years, **Ross Chapple** has produced award-winning landscape and Bicentennial photographs for the U.S. National Park Service. He has photographed scientific subjects for the Smithsonian Institution, and his photographs of architectural interiors have appeared in *Better Homes & Gardens* magazine. Photographing São's work proved to him to be as exciting a challenge as any that he has had thus far.

TEXT BY NANCY GRUBB,
IN COLLABORATION
WITH MARIA DA CONCEIÇÃO

PHOTOGRAPHS BY ROSS CHAPPLE

FOREWORD BY LLOYD HERMAN

A STUDIO/PENGUIN BOOK

WEARABLE ART

MARIA DA CONCEIÇÃO

INNOVATIVE DESIGNS FOR CLOTHING AND FIBERS

Penguin Books Ltd, Harmondsworth,
Middlesex, England
Penguin Books, 625 Madison Avenue,
New York, New York 10022, U.S.A.
Penguin Books Australia Ltd, Ringwood,
Victoria, Australia
Penguin Books Canada Limited, 2801 John Street,
Markham, Ontario, Canada L3R 1B4
Penguin Books (N.Z.) Ltd, 182–190 Wairau Road,
Auckland 10, New Zealand

First published in the United States of America by
The Viking Press (A Studio Book) 1979
Published in Penguin Books 1980

LIBRARY OF CONGRESS CATALOGING IN PUBLICATION DATA
Maria da Conceição.
Wearable art.
1. Costume design. 2. Textile crafts.
I. Grubb, Nancy. II. Title.
[TT507.M348] 646′.34 79-18009
ISBN 0 14 00.5332 8

Text and black-and-white photographs printed in the
United States of America by Halliday Lithograph, Hanover, Massachusetts
Color photographs printed in Japan by
Dai Nippon Printing Company Ltd., Tokyo
Set in Times Roman

Color photographs are by Ross Chapple
with the following exceptions:
plates 3 (Joel Breger), 4 right, 5, 12, 14,
17, 25, and 31 (John Tennant).

CONTENTS

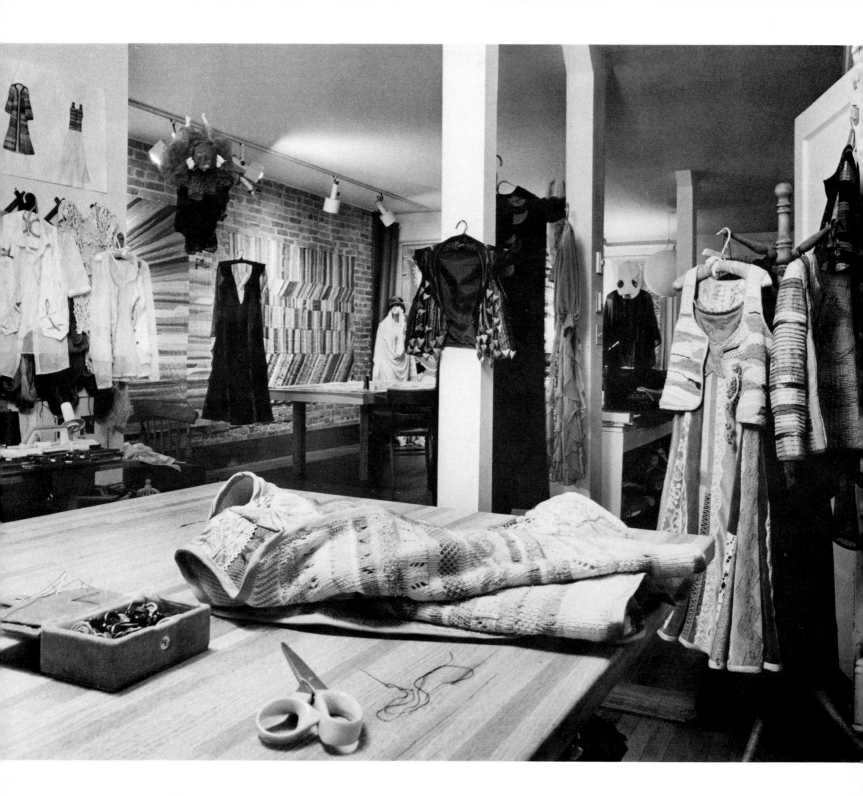

FOREWORD

Twenty years ago, when one spoke of "personalized" clothing the reference was to a monogram embroidered on a lapel or pocket. The conservatism of clothing in the 1950s gave way to embroidered blue jeans and tie-dyed tops in the '60s which, although they became almost standardized as counter-culture uniforms, expanded our recognition of clothing alternatives. Today, the possibility of choosing clothing to suit one's moods and occasions seems almost limitless; it is no longer shocking to see extravagant costuming worn for less than purely theatrical events.

Craft books, in great proliferation and of all descriptions—for the collector as well as the craftmaker—report on virtually every aspect of utilitarian and art craft today. It had not occurred to me that the increasing popularity of personalized clothing had not been touched by the publishing business until Maria da Conceição—"São" as she is known creatively—told me that she was working on a book about her wearable art. I knew her work from exhibitions, but saw it far more often on artists and other collectors who wear the garments she has created to art and social occasions in Washington. A book on how she makes such wearable art seemed a good idea.

Now the book is written, and photographs have been made of numerous examples of São's work. In viewing her photographs for the book, I admit to being amazed that she had created such a rich variety of work that was unfamiliar to me. It pleased me even more that she had chosen to share her personalized response to the colors and textures of fabrics and laces with a broader audience through this publication.

São's book should enable others with an artist's sensitivity to texture and color to employ the heretofore homely skills of sewing, embroidery, knitting, and crochet to give personal character to their own wardrobes, and to enjoy the sense of pride that goes along with wearing a "work of art."

Lloyd E. Herman
Director
Renwick Gallery
Smithsonian Institution
Washington, D.C.

"WEARABLE ART": AN EXPLANATION

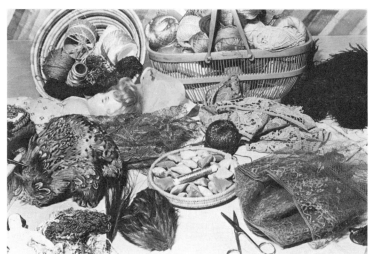

The decision to make a book of my "wearable art" started with the growing desire to share my work beyond just selling and exhibiting it. By "wearable art" I mean pieces that are timeless, artistic, and unique, but not so extravagant that they cannot be worn by most people. Unlike fashion, which reflects the fleeting preferences of a season's market, wearable art may be worn for different occasions throughout the year, while continuing to make its wearer feel special for an endless number of years. To me, creating a piece of wearable art requires a certain amount of thought, design, self-criticism, visual concern, and awareness of personal preferences for particular colors, patterns, and detail.

Throughout history, clothing has served as a medium of expression, from the statements of status made by the fashions of the wealthy and stylish to the sense of community passed down through traditional folk costumes. But for most people today, clothing as a means of self-expression is limited to the ready-mades available on the market. I feel there is an increasing need for more individual expression in what we wear.

By using photographs and describing my techniques and ideas, I hope to inspire readers to create clothing that conveys personal choices in terms of color and design, that reveals a particular mood, and that communicates a self-image or a favorite fantasy.

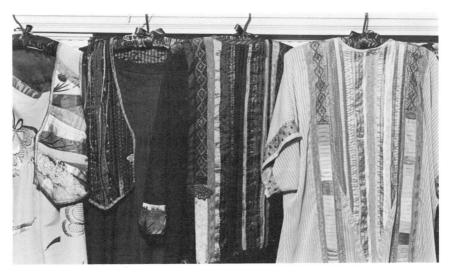

There are many books with instructions and illustrations about patterns, stitches, and techniques that teach the basic mechanics of sewing, stitchery, knitting, and crochet. It is the purpose of this book not to demonstrate how to do these things, but rather to inspire in the reader a sense of color, design, and style that she may otherwise be too timid to use.

The photographs on the following pages show the development of several pieces in the hope that the reader will put in a little more time and self on a piece of handmade clothing. Unlike step-by-step instructions that often prove to be discouragingly complicated and time-consuming for the beginner, this book is intended to stimulate the reader's own ideas and imagination. Many easily available materials—out-of-date dresses, leftover fabrics, simple patterns—can be used as a background for the most imaginative and personal compositions. The same principles, techniques, and tools can also be used to transform furniture and accessories to heighten the visual appeal of the home.

There is no end to the variety of ideas that come once you start to experiment by combining different techniques, mixing different textures, and using your sense of color and design. I hope that by the end of the book you will be inspired to become the creator of your own very personal statements.

—Maria da Conceição (São)

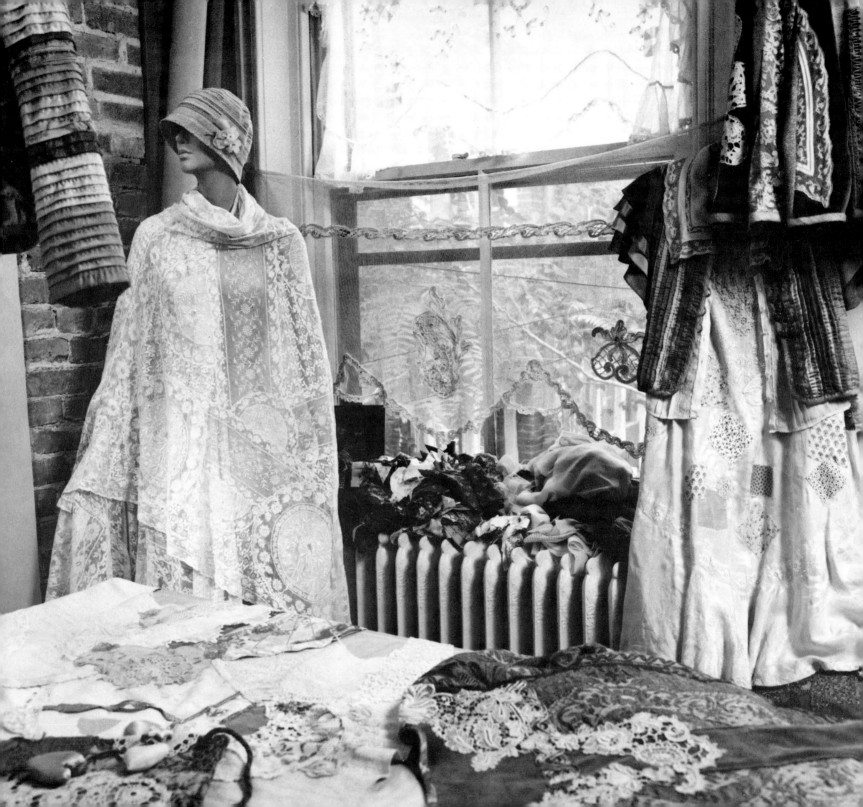

THE ARTIST AND HER STUDIO

Like the birds that often figure in her imagery, São has made herself a nest: the large studio where she works is feathered with her art and her materials, her work and her pleasures. Light pours in through lace curtains, throwing intricate shadows across the wooden floor. Texture, color, and warmth are everywhere. It is a peaceful place, a haven where every surface delights the eye and tempts the touch. But it is as enlivening as it is peaceful, for São's own restless creativity sparks the atmosphere. After sitting a bit and absorbing the ambiance, one cannot resist wandering around, poking into corners, fondling the silks and ribbons, thumbing through the sketches, studying the hangings.

It was here in her studio that São and I spent the better part of one summer and fall, drinking tea and talking. Rather, São would talk and I would write, scribbling to catch the rapid flow of her ideas. Every once in a while she would jump up to find something she needed to make a point more clearly—pulling out bags of material collected over the years, to illustrate how her color sense had evolved; working a few rows on the knitting machine to demonstrate the stitches she'd invented; folding and pinning scraps of fabric to show how her various pleats and ruffles are constructed. This book is the result of those many lively sessions—I can only hope it offers the reader as much pleasure, information, and stimulation as the process of making it gave to us.

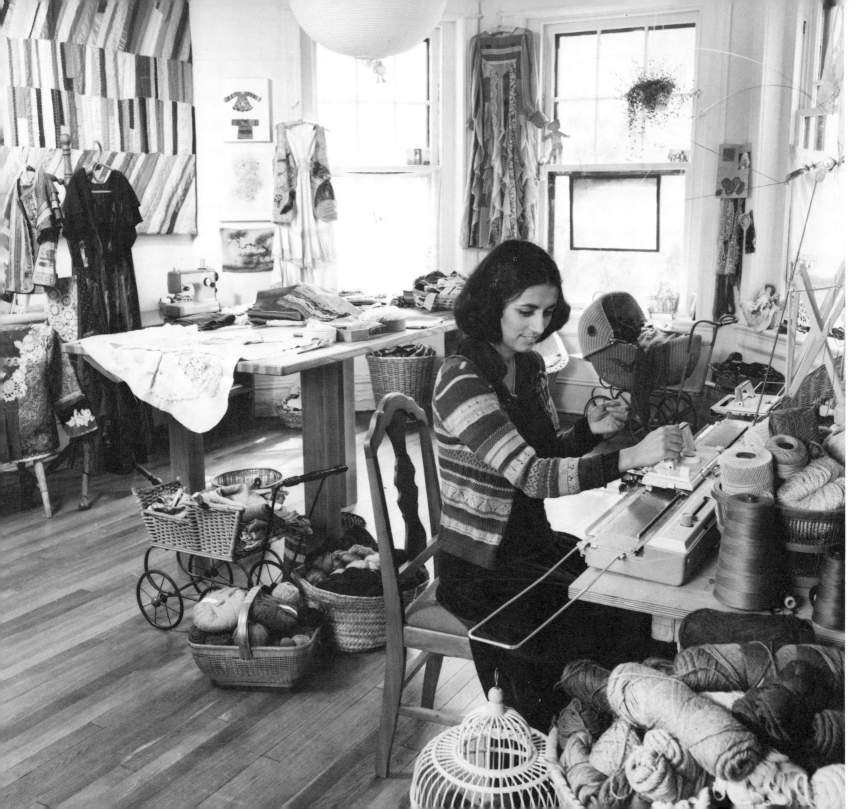

That São's creative energy is balanced by a tremendous sense of discipline is obvious from the well-ordered organization of her studio. Along one wall sits a sewing machine with threads, needles, and ribbons within easy reach. Ranged around it are baskets of lace and an old-fashioned baby carriage brimming with silks. On the opposite wall is a knitting machine encircled by baskets and birdcages full of natural yarns. Two large wooden tables stand in the room. Long, low shelves hold files of fabric divided by color, weight, and style, as well as books and portfolios filled with pieces created in the past. On the windowsills sit small boxes and baskets filled with buttons, unusual clasps, snaps, and other accessories for future use. Plumed dolls swathed in lace and satin float surrealistically from the ceiling. A coiled soft snake lurks in a corner. Watercolor sketches lean against the baseboards. And suspended from the mantelpiece, draped on mannequins, hung from windowsills, and strewn across tables and chairs are vests, skirts, dresses, sweaters, jackets, hats, and capes in all stages of completion.

Just as a nest identifies the bird that built it, so São's studio reveals her artistic identity. The presence of nature is very strong here, but it is not the raw organic nature of ethnic artisans and back-to-the-earth craftsmen; it is nature refined and civilized, interpreted by a sophisticated sensibility, by eyes and hands trained in the European tradition of fine craftsmanship.

Intensely serious about her art, São works constantly—experimenting, exploring. Wall hangings, wearables, dolls, soft sculpture—she is intrigued by them all, intrigued by what she can do with them, by how far she can develop them.

Each work day is spent in the studio, sketching, cutting, stitching. When she is not actually planning and constructing pieces she is out prowling through shops, looking for the natural fabrics she insists on using. Antique stores are also a favorite haunt, where she might discover some rare bit of lace, an evocative doll, an old silk kimono.

São was born in Evora, Portugal, an ancient town so filled with Roman and Moorish ruins, with churches, monuments, and palaces that it is known as the "museum town of Portugal." The stone house she grew up in is four hundred years old; the convent where she studied is even older. Christened Maria da Conceição, she has been nicknamed São ever since she can remember, and has always used that as her *nom d'aiguille.*

In addition to the standard course of academic studies at the convent, she was taught the full range of traditional Portuguese crafts: embroidery, crochet, knitting, lace making, paper cut-outs, fabric flowers. It was not until São moved to Denmark in 1964 that she began to study art and, even more important, began to consider herself an artist. As soon as she arrived she became involved with the Danish Handcrafts Guild, discovering that the traditional techniques she had learned in Portugal were in great demand and rare supply. Later, as she continued her studies, she began designing her own work.

São once commented that "in Scandinavia they use bright colors to take the place of the sun they don't have." These colors proved irresistible: her work of this period radiates light and warmth. The stripes that have since become a favored motif she derived in part from the traditional Scandinavian "Fair Isle" knitting patterns, which again feature brightly contrasting colors. Her preference for natural materials also dates from this period, for most of her teachers and colleagues used only organic fibers and dyes.

But far more essential than the influence of color and style was the sense of herself as an artist that São developed in Denmark. Suddenly her own creativity emerged, and she recognized that all the skills she had learned so far were simply tools to be used in her own self-expression.

São came to America in 1974, settling in Washington, D.C. Aside from giving occasional classes and lectures, she devotes most of her time to her art. Synthesizing all her earlier experience, she has evolved a style uniquely her own.

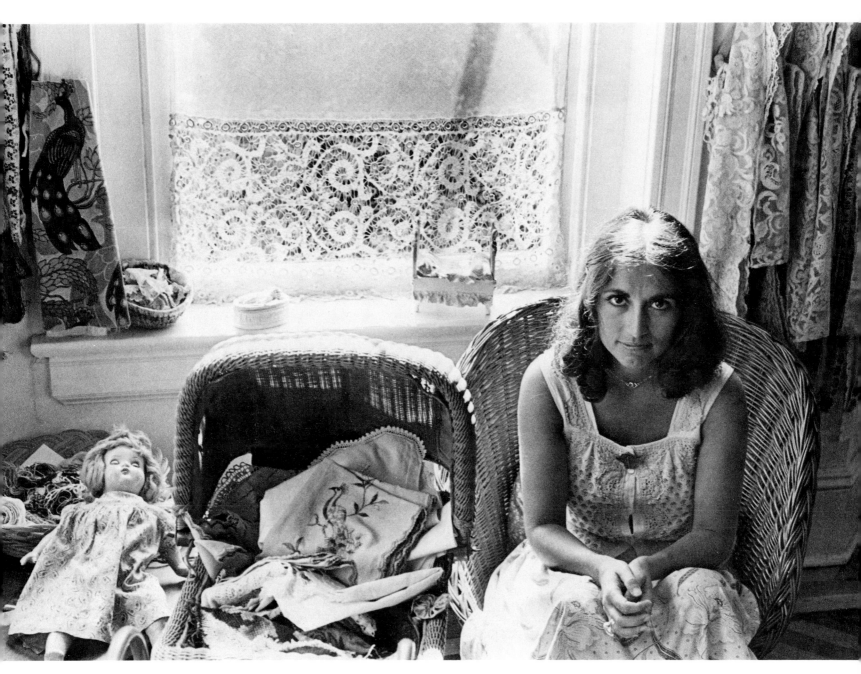

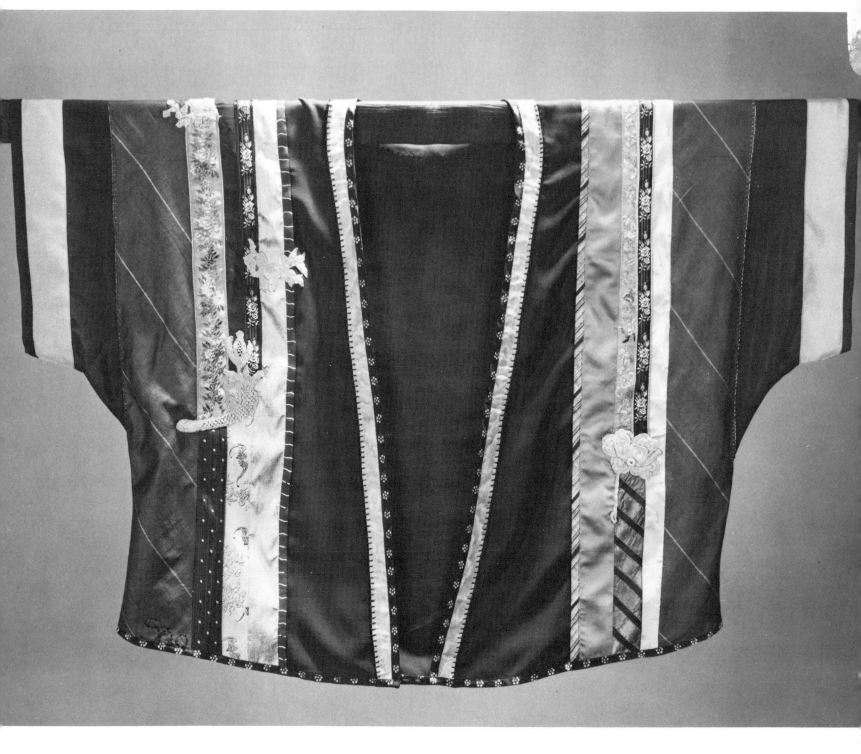

1. CLOTHING

The basic necessities may have started out as food, shelter, and clothing, but somewhere along the line they evolved into cuisine, architecture, and fashion. Humanity's first response to knowledge of good and evil was to reach for a fig leaf; and clothing has been a complex issue ever since, expressing far more than simple modesty.

Eroticism, for example, is revealed more clearly by clothing than by nudity. Perhaps the most blatant erotic statement was made by the Greek courtesans, the soles of whose sandals were carved out with the words "Follow me." As they walked in the dust, their sandals spelled out this evocative message. Nearly as bold were the European gentlemen of the fifteenth and sixteenth centuries who wore bright codpieces that advertised their masculinity while providing a convenient storage place for loose change and bonbons. As erotic preferences came and went, Elizabethan ladies strapped on leather corsets and whalebone farthingales; their Napoleonic counterparts stripped to silk tights and sheer muslin gowns; flappers flattened their breasts and raised their skirts.

An obvious sign of the wearer's wealth and status, clothing has long served as a handy social marker. In ancient Rome the right to wear a white toga was granted only to citizens, while the lower classes wore brown and black garments. When the newly prosperous bourgeoisie of fourteenth-century France began to copy the fashions of the nobility, the ladies of the court retaliated by embroidering their robes with the family crests (husband's on the right side, wife's on the left)—proof of their aristocratic lineage and sure distinction from their upstart imitators. Centuries later, Victorian ladies demonstrated their genteel inutility and displayed their husbands' wealth by swathing themselves in yards of fabric and pounds of crinolines.

Campaign buttons and straw hats with slogans may be the most familiar examples, but political statements have been worn in a variety of more or less subtle ways. When Peter the Great decided to modernize Russia, he commanded his boyars to abandon their traditional costume for European dress, and anyone caught reverting to Russian garb was apt to be severely punished. The radicals of the French Revolution were dubbed *sans-culottes* because they exchanged the knee breeches of the court for the trousers of the lower class; at the height of the Terror to be seen wearing short pants was grounds for the guillotine. A more charming expression of political sentiments was made by the Royalist ladies of the Restoration, who wore white dresses decorated with eighteen tucks to indicate their support of Louis XVIII. Later in the nineteenth century, women used fashion to make a far different statement, and bloomers became a symbol of female emancipation. The public outcry that greeted this "immoral" style had its echoes in the scandalized response to the bra burnings of the 1960s.

Avant-garde artists at the beginning of this century pledged to dissolve the distinctions between fine and applied arts and to extend the new aesthetics into all realms of life, including fashion. Earlier examples of such involvement are rare. The eighteenth-century French artist Jean Antoine Watteau painted so many women wearing a certain style of free-flowing robe that it is now known as a Watteau gown, and he is apocryphally credited with having designed it. Elisabeth Vigée-Lebrun—favored portraitist of Marie Antoinette and other pre-Revolution nobility—comments in her memoirs that "as I greatly disliked the style of dress worn by the women at that time, I did my best to make it a little more picturesque, and whenever I obtained the confidence of my models I delighted in draping them after my fancy." Her flattering images of women clad in simple white gowns helped establish the popularity of the neoclassical mode.

Not until the early 1900s did artists again have such an evident impact on fashion. Paris of the first two decades of the twentieth century sizzled with creativity, and it was there that some of the most inventive artists were making costume an art form. When impresario Sergei Diaghilev brought his Ballets Russes to Paris in 1909, he had already worked in Moscow with such artists as Natalia Goncharova, Mikhail Larionov, and Léon Bakst. Once in Paris, he collaborated with Picasso, Braque, Matisse, Miró, Rouault, and many others of the avant-garde, who produced an amazing variety of innovative costumes and sets for his productions. In Paris at the same time was the expatriate

Photo: Joyce Tenneson Cohen

Russian artist Sonia Delaunay. A painter who worked with her husband, Robert Delaunay, in developing the vibrant style called Orphic Cubism, Sonia applied the same principles of abstract color harmony in creating tapestries, textiles, and the famous "simultaneous" clothing she and her husband wore to the jazzy Paris nightclub Bal Bullier.

Whatever its sexual, social, political, or aesthetic implications, clothing is ultimately a matter of personal choice, a public statement of private preferences. This is true regardless of whether one selects clothes designed by others or whether one designs one's own clothing, but obviously the more direct the involvement in their creation, the more direct the reflection of a personal identity, a personal aesthetic.

Earth and sky, landscape and wings are images that recur throughout São's work, and they can be seen in much of her clothing. The airy lightness of her white silk crepe de chine winged shawl contrasts with the dark, earthy richness of her landscape cape—complements from both ends of her personal spectrum. The shawl is appliquéd with lace and patches of an-

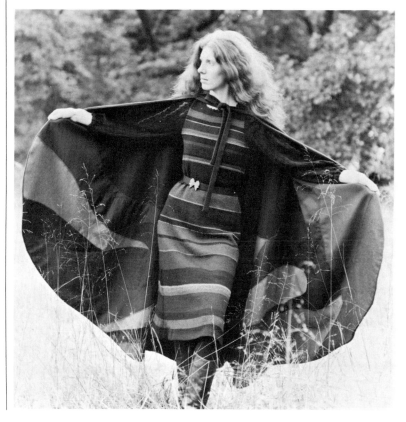

tique and contemporary silks, and a narrow band of bobbin lace finishes the edges; the reversible wool cape is hand appliquéd with wool. Each shape is outlined with a line of backstitch worked in cotton floss. The gray bird cape offers another vision of flight—soaring, mysterious, a bit forbidding—an eagle in comparison to the swanlike shawl. The cotton velour cape is machine appliquéd with cotton and velveteen

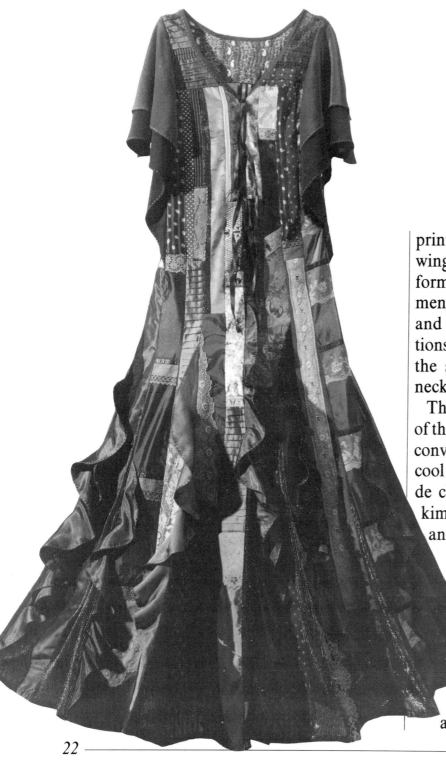

prints. In the striped silk dress (see also plate 4), wings have become flowing sleeves and free-form ruffles, rippling with the slightest movement, catching every gleam of light. Old laces and embroideries were dyed in multiple variations of wine, rust, blue, and gray to blend with the silks and lamés. The ruffles, sleeves, and neck are hemmed with gold thread.

The dark, almost severe, geometric simplicity of the kimono-inspired vest (page 16 and plate 7) conveys a sophisticated elegance and projects a cool mood. Here the base is a solid color crepe de chine, the pattern a simple, old-fashioned kimono. Strips of printed and solid color silks and cottons have been machine appliquéd to the base, then folded over to cover the stitches. Some of the loose edges were stitched by hand or highlighted with several different stitches; others were covered by cotton laces.

The bright colors and bold, playful shapes of the appliquéd vest (above right and plate 3) suggest a bouncy cheerfulness.

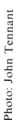

Made of a solid color linen cut in a simple pattern, the vest was appliquéd with an abstract composition of silk, satin, cotton, lamé, brocade, and other fabrics, then embroidered with cotton, silk, linen, and metallic threads, using stitches such as chain, back, buttonhole, blanket, and running, French knots, wheels, and any others that came to mind. Multi-colored beads were also sewn on to add an extra note of playfulness.

Many of São's wearables incorporate references to past experiences. Like patchwork quilts made of scraps from favorite dresses, they capture memories of other times and places. São crocheted the piece that she calls "Badlands Vest" (left and plate 17) while riding in a car across the United States, using yarns picked up at stops along the way. Single and double crochet are combined with shell stitches in a free-form design that took its shapes and details from the passing scenery—the Dakotas and the Southwest. The pale shades of bleached desert and sandstone canyons are all recorded. Occasionally an area of a solid color is outlined with a single row of straight stitches in silk or metallic yarn to highlight the edge. (This vest reverses to a fabric collage of cottons, silks, and laces.)

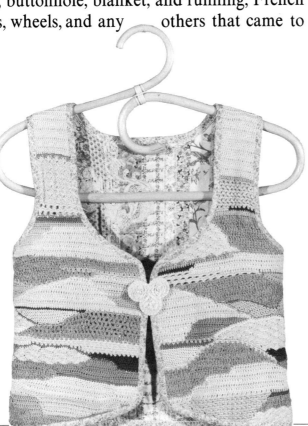

Another very personal piece—a collage skirt (see also plate 24)—is almost a scrapbook. Silk from a tablecloth, a corner from a handkerchief, a lace shirt collar, a strip from a 1940s silk kimono were used, as well as: old and new fabrics; laces from the three hope chests full of bedspreads, towels, and pillowcases she made as a dowry before leaving Portugal. All of these are fashioned into a skirt that expresses both her experience and her aesthetic with delicate grace.

While especially responsive to her own favorite colors, shapes, and textures, São remains open to whatever new influences and inspirations she may encounter. As she has noted: "I feel that I can explore any color or style without conflicting with my own personal preferences. When I make clothes, I think of what would look best both on myself and on different types of people. I like to emphasize femininity (without overdoing it or falling into clichés), but this does not mean that I am limiting myself or eliminating other possibilities."

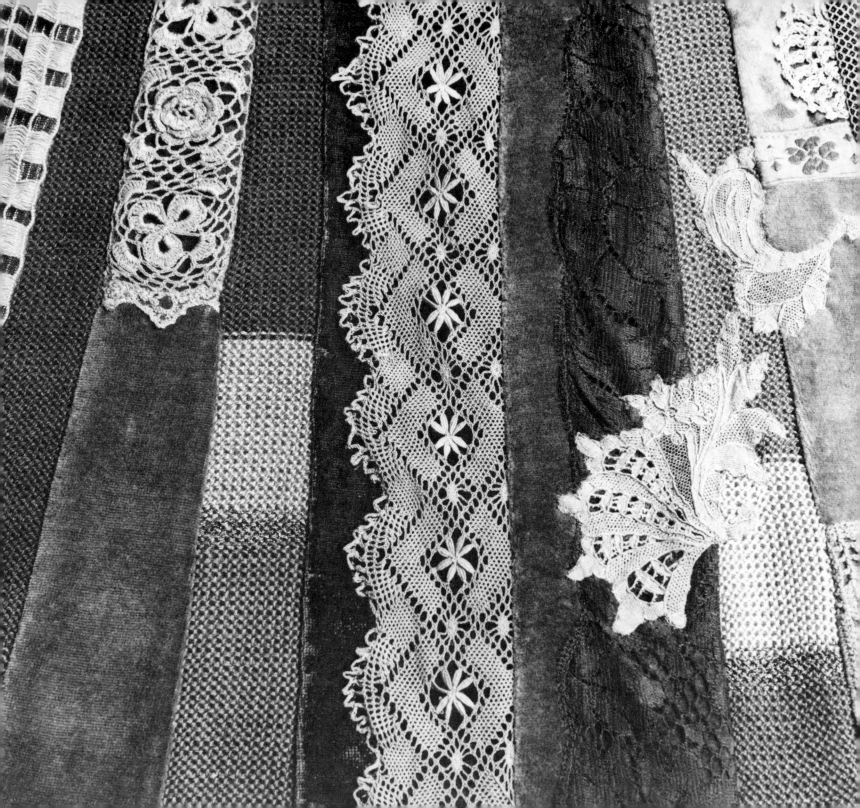

2. THE BEGINNING

Many times an appealing piece of fabric, lace, embroidery, or even just a favorite scrap will provide São with the initial inspiration for a new design. Her next step is to gather together other materials that she can foresee using in the project, whether it be a dress, vest, jacket, or a wall hanging. Not everything in the original pile may ultimately get used, but having the fabrics there to choose from is important, and their gradual selection is an essential part of the creative process.

After the initial choice of fabrics has been made São begins to work on the actual design of the garment she is going to create by drawing it first. Because color is so important in her work, she generally uses watercolors, and her sketches are usually quite explicit, clearly indicating not only the design of the garment itself, but also the shapes and colors of the individual elements within it. The overall design is almost always extremely simple—an A-line dress, a three-piece vest, a flared skirt—the complex interplay of color, pattern, and texture provides the visual focus, and the shape of the piece itself should offer no distraction.

If it seems too complicated to design a pattern from scratch, a simple commercial pattern can easily be used as a starting point. It is, of course, a good idea to work with a pattern that can be trusted to fit, and if no one pattern includes all the desired elements, two or more patterns can be combined. A very plain dress pattern, for instance, can be enlivened by the addition of elaborate sleeves, which have been based on another pattern.

Once the fabrics have been chosen, the design sketched, and the pattern determined, the real work begins.

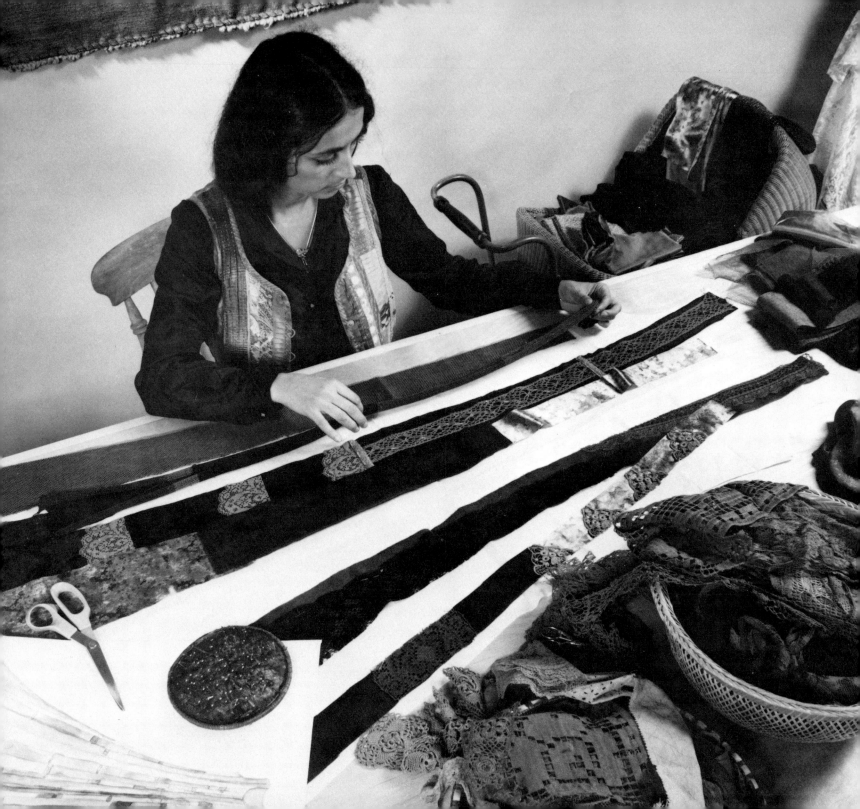

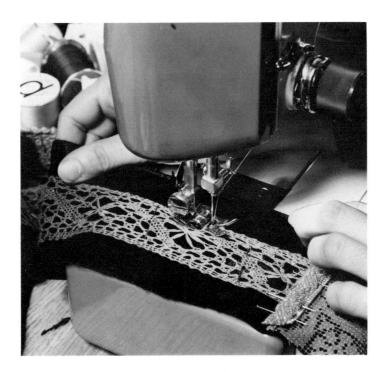

If the project is a simple patchwork dress (page 31), the master pattern should be folded into strips and a separate paper pattern cut for each strip. Each of these patterns is then used to make a panel which can be a solid or print fabric—appliquéd with lace, for instance, or left as it is—or a knit or other unusual weave. Each panel should always be cut with at least a quarter-inch seam allowance on all sides. After all the strips or panels have been cut and embroidered, appliquéd, or highlighted in whatever other way one chooses, they are machine stitched together. These strips are then treated as any solid piece of fabric would be—the mas-

ter pattern is pinned to the "paneled" material and the dress is cut. The dress is composed of two pieces—front and back—which are joined by machine at the shoulders and the sides. The dress should then be tried on, the darts marked, and any necessary adjustments should be made.

At this point, additional laces, ribbons, and embroideries can be appliquéd over the patchwork—to soften a transition between two highly contrasted fabrics, to camouflage a seam, or to provide a dash of visual punctuation. After all the appliqués have been stitched down, the lining—already chosen, cut, and constructed—should be sewn in. Any raw edges should be bound with a bias strip, which can be cut from a complementary print or solid color to add another decorative note.

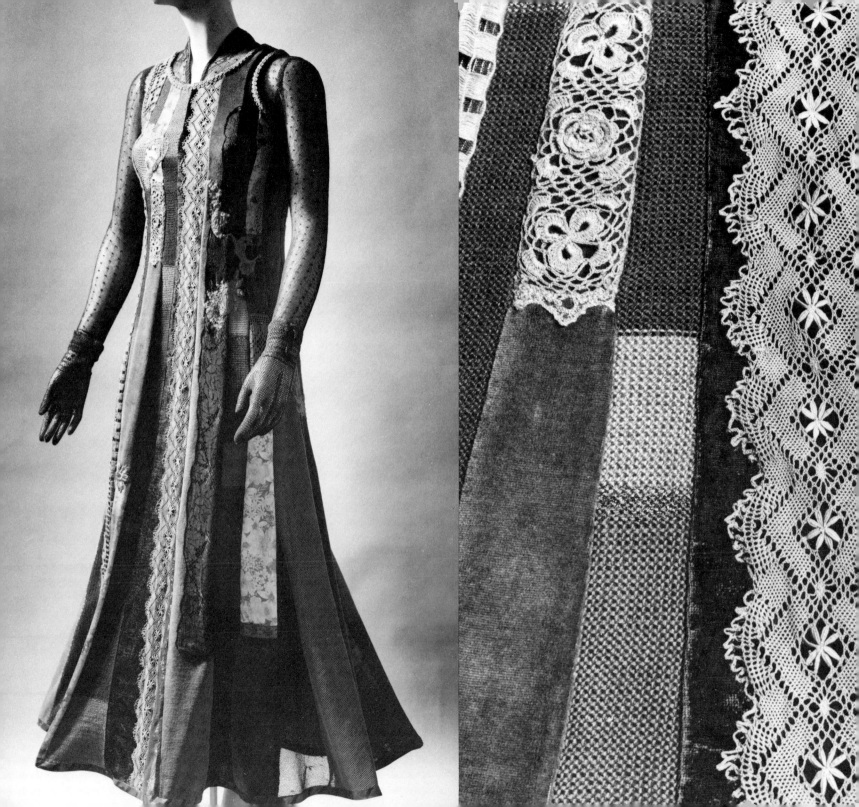

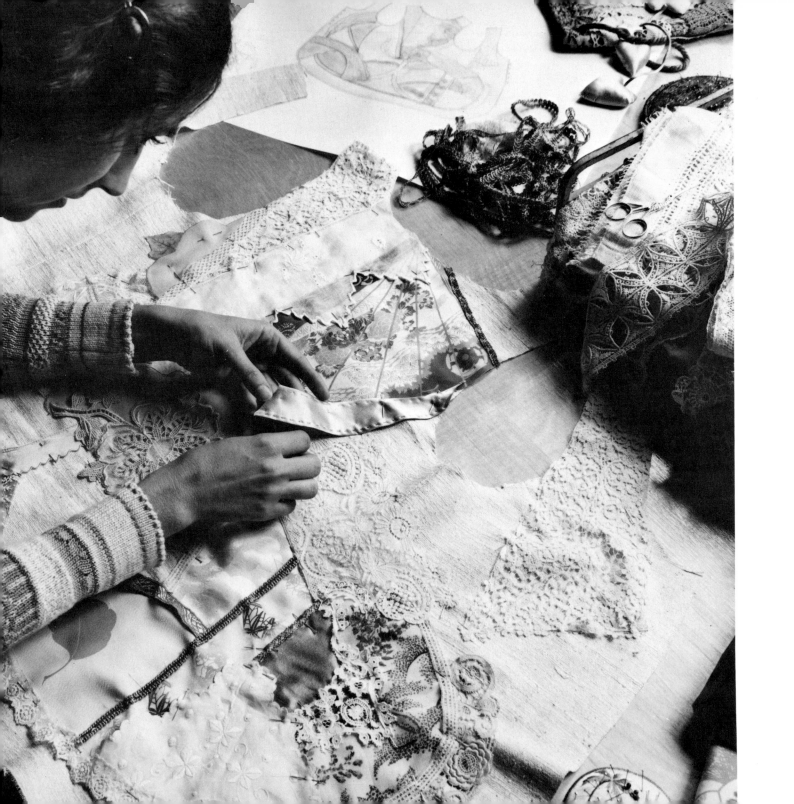

When São makes one of her free-form collage vests (page 34), the original watercolor sketch is even more important, since it provides a guide to the size and shape of each individual piece. The pieces are cut according to the sketch, then pinned to a lightweight fabric base, generally silk or a fine cotton which has already been cut from a pattern. Once any rearrangements of the composition have been made, the edges of each piece are pressed under and the pieces are then all machine stitched into place.

The lines of these stitches form a decorative pattern that may be left visible, or a separate lining may be added. Again, the raw edges should be finished with a bias strip. This strip can also be embellished—even the simplest embroidery stitch worked in metallic or silk thread polishes off the edges in a very lovely way, and the time and thought given to such details reflect one's own personal taste in a way no mass-produced clothing ever can.

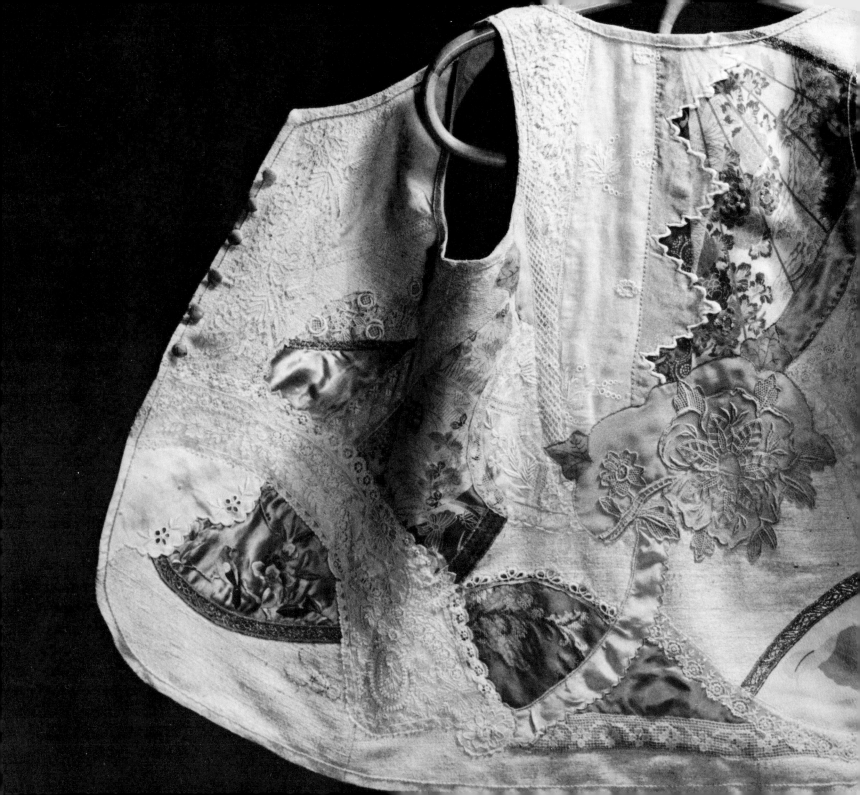

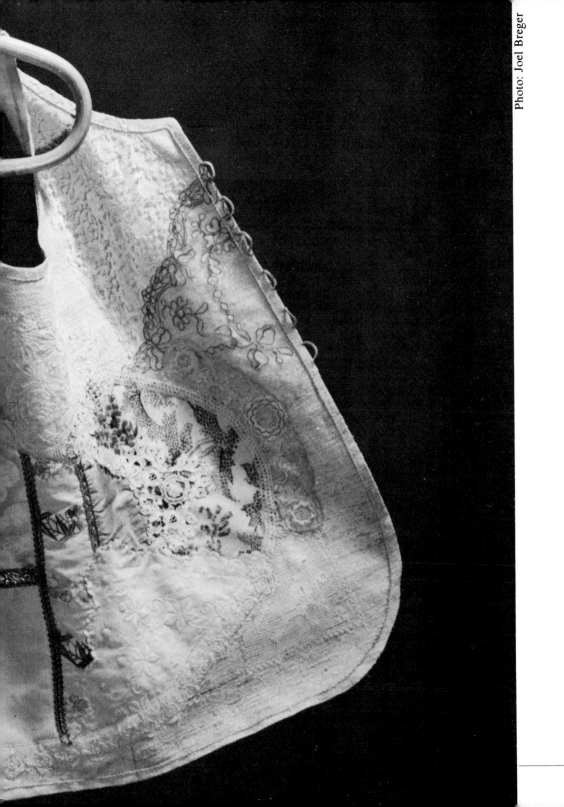

Photo: Joel Breger

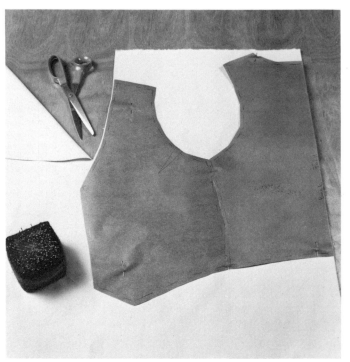 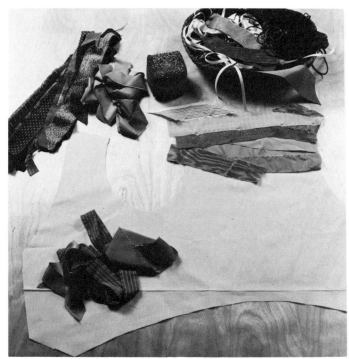

For another collage vest (page 39), São used a simple pattern with seams only at the shoulders. After she cut the lightweight cotton that was to be used as the vest's base she gathered together all the materials that she intended to use and began to cut pieces free hand, paying attention to the overall composition and play of colors. The individual pieces were pinned to the cotton base before they were sewn on. She then used machine and hand stitches, laces, ribbons, silk cords, and old and new buttons to unify the collage and to give it a three-dimensional look.

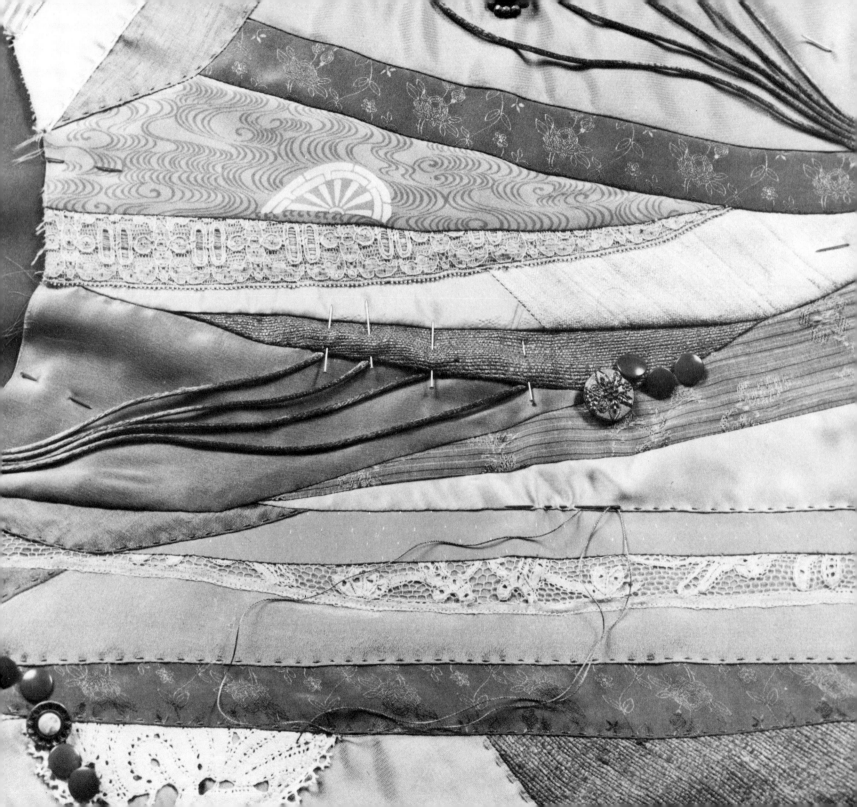

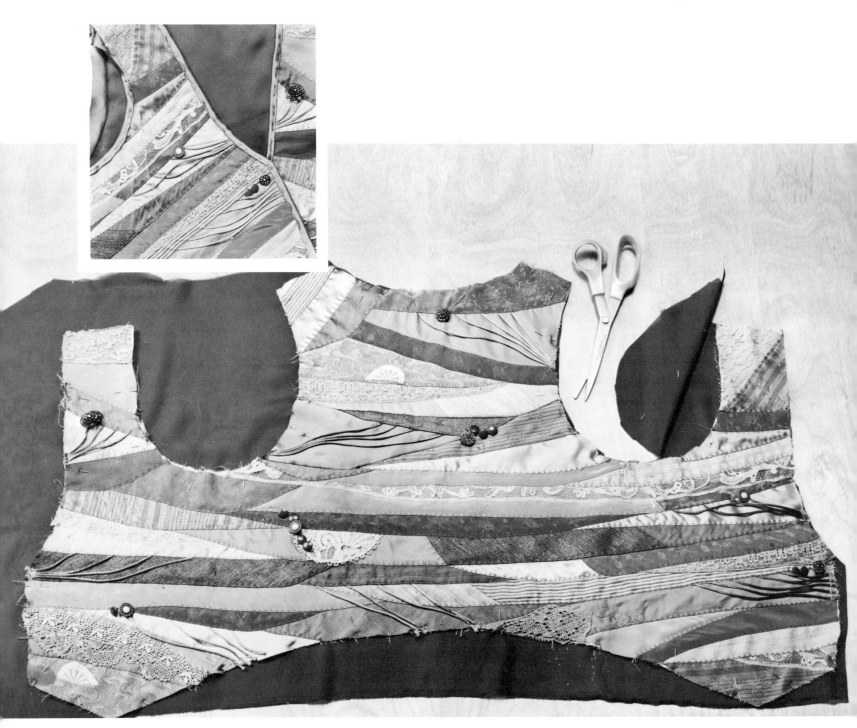

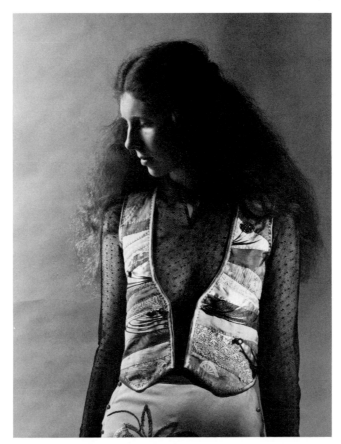

Once the collage was sewn together and the last touches finished, she cut a lining with exactly the same dimensions as the vest, choosing a fabric that was compatible with the colors and composition. After the lining was constructed and the darts added, she cut a bias strip from another fabric to bind all the edges. This bias trim was machine sewn on the lining side, then folded over to the front, basted, and finished with a favorite hand stitch in thread that complemented the rest of the piece. At that point she had the option of adding unusual buttons with hand-embroidered loops or machined button holes or leaving the vest plain so that the wearer could choose to use a pin or clasp if she preferred to wear it closed. The vest is worn with a skirt of matching colors and a black lace blouse.

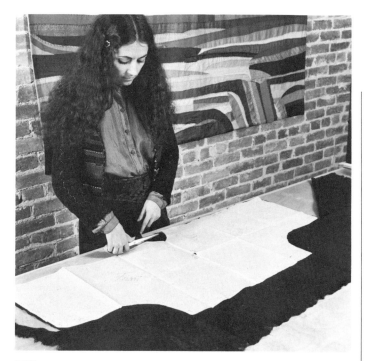

and she appliquéd only a few stripes of silk, lace, and ribbon along the front and back and at the sleeves. These stripes were machine sewn to the lace, then hand stitched with silk. She carefully considered the overall effect before choosing a hand stitch to finish off each seam. Square patches, lace flowers, and leaves cut from larger pieces were then added to break the lines of the stripes. A bias strip of slightly contrasting silk was hand sewn around the edges to highlight and emphasize the lines.

For a kimono-style jacket (page 44), São used a very simple kimono pattern that required only two side seams and no darts. Once the lace she chose to use as the basic material had been spread out on the table and cut according to the pattern pinned to it, she began to design the collage to be appliquéd over it. She experimented with various pieces of fabrics in different widths, then pinned them to the base before basting them down. To maintain the transparency of the lace, no lining was added,

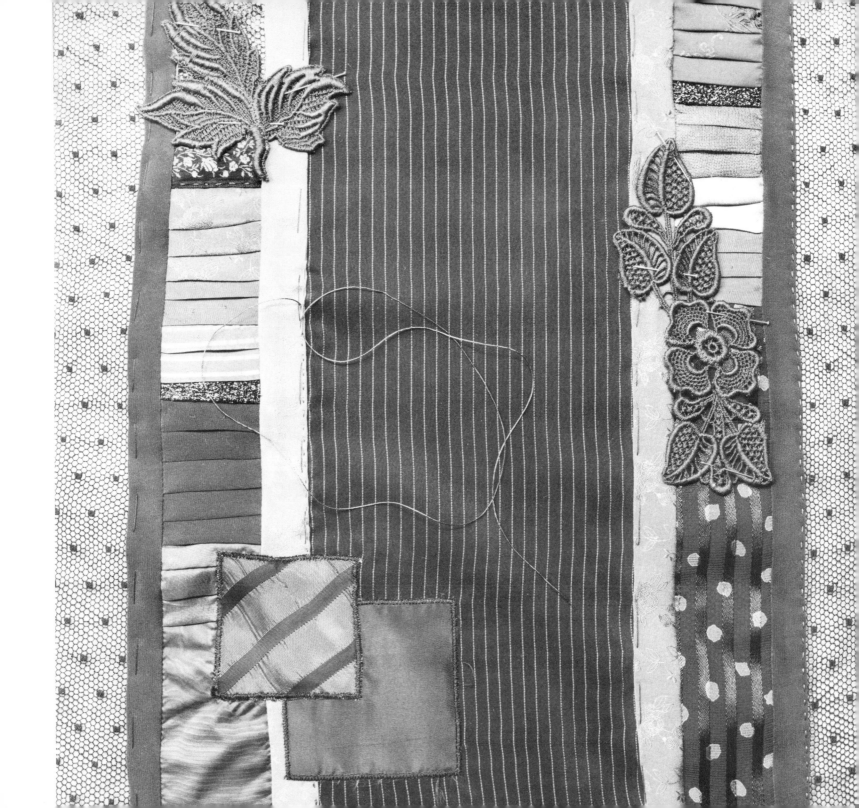

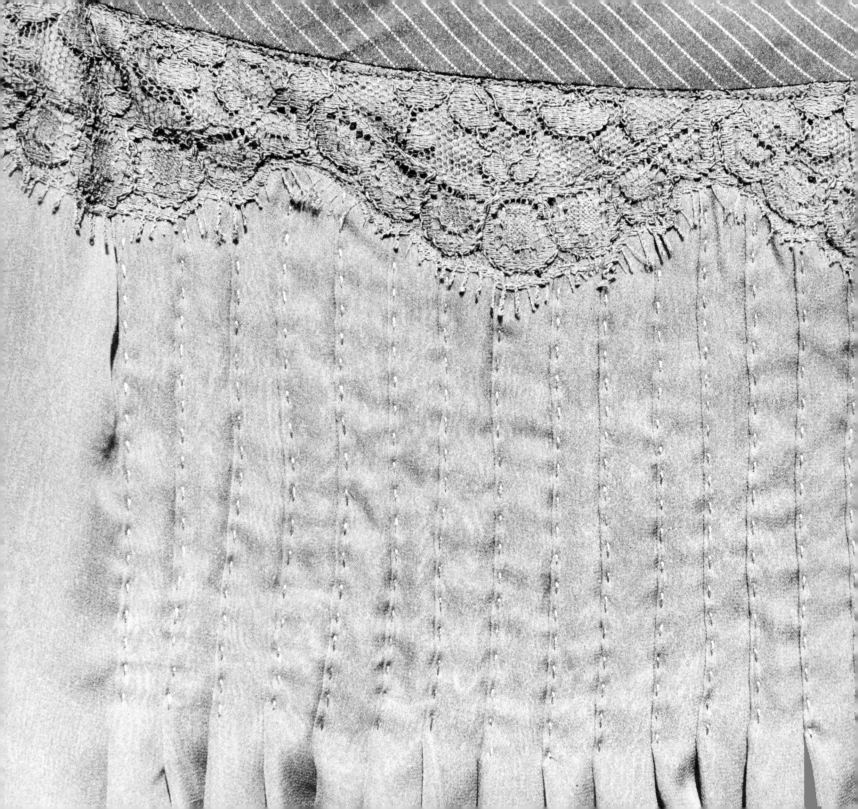

To go with the kimono, São made a skirt of crepe de chine, with an over layer of chiffon. A silk lining measuring seven inches from waist to hip, both front and back, was used to give extra support to the fragile fabrics. A band of pleats, also measuring seven inches, was made of the top two fabrics and pinned to the lining, then sewn by hand with silk thread in a flat basting stitch. A border of striped silk was appliquéd along the bottom to outline the edge of the silk and to hem it; the chiffon was hemmed by hand with the same thread and stitch as the pleats. For the waistband São used a piece of the same striped silk and scallops of old lace. The same effect of transparency was continued by using old black lace to make a sleeveless blouse from a simple pattern.

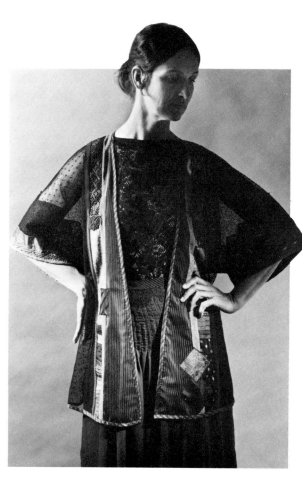

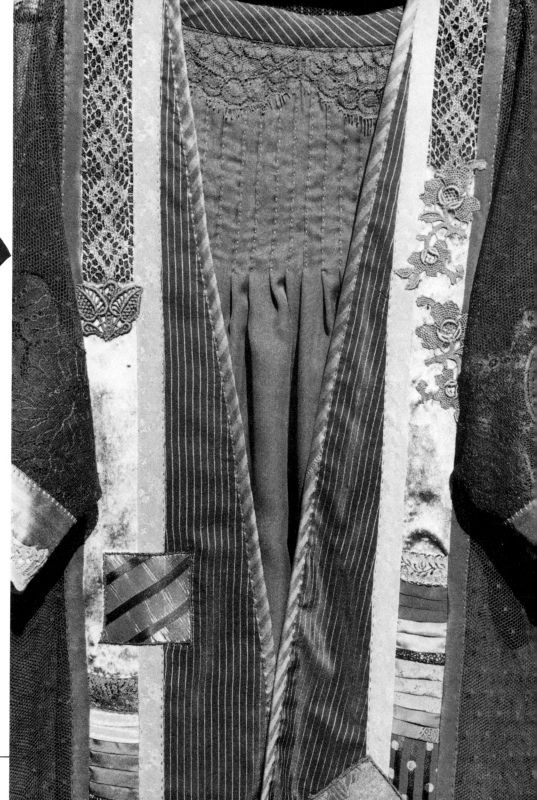

A simple pattern is all one needs to get started with a collage or pleated jacket (see plates 6, 8, and 12). To provide more opportunity for surface design, the back can be cut into two pieces: take the back piece of the pattern and cut it across from the armholes to the center fold in a straight line or a V-shape. One can then appliqué stripes or pleats going horizontally on the top piece and vertically on the bottom. The front pattern can also be cut into two pieces: either from the armhole straight down the side to the bottom or across the front to make a yoke. Here again one can make use of the two pieces to combine opposite lines.

Straight sleeves can be made more interesting by adding extra fabric along the center fold, then gathering the shoulders to create a puff sleeve. The same pattern of stripes or pleats from the body can be continued onto the sleeves to unify the composition.

Fabrics, lace, ribbons, and whatever else is chosen for the collage can be appliquéd directly onto the silk or cotton lining, and each line or pleat can be hand-stitched with metallic, silk, or cotton floss. The stitches will show on the lining, giving the inside of the jacket a quilted look. The seams can be hidden with a bias strip of the lining material sewn into the seam, then folded over and stitched down by hand. A different bias strip can be used to finish the outer edges of the jacket; it should be a fabric that will complement both the jacket and the lining.

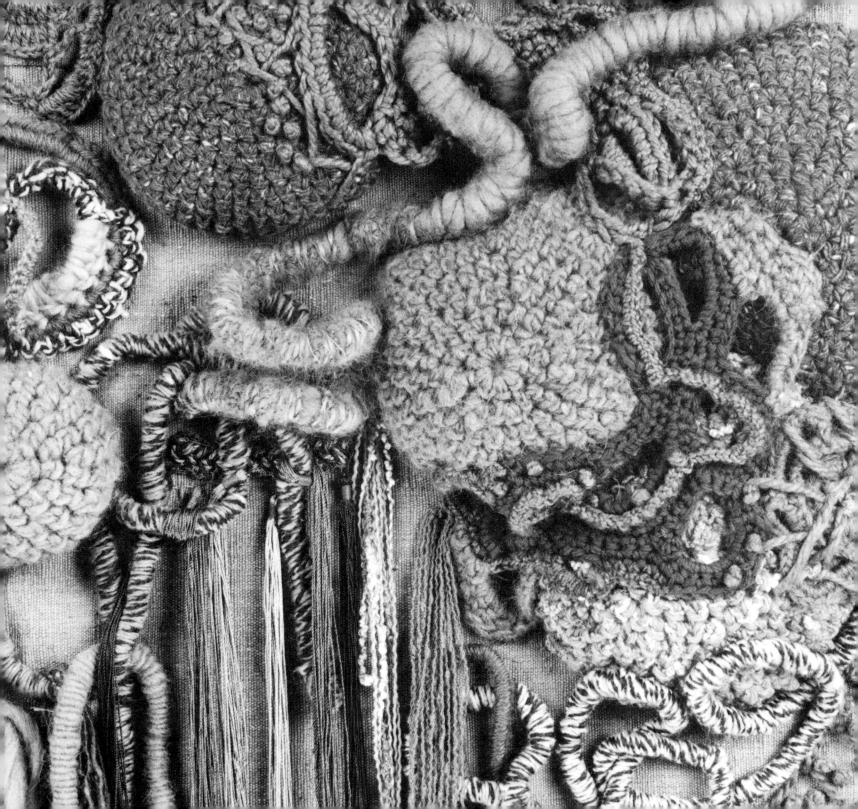

3. COLOR, TEXTURE, AND PATTERN

Three elements—color, texture, and pattern—provide the basic themes for a multitude of variations.

The colors that São now uses are richer, softer, and more complicated than the bright and shiny hues of her earlier work. Purple has given way to mauve, orange has paled to apricot, turquoise has softened to smoky gray. There is a pivotal piece that demonstrates this transition: the bold colors of the fabric collage that she calls *The Five Elements* (see plate 2) are characteristic of her early work, but the roses, plums, and tawny ochres of the intertwined fibers along the lower edge foreshadow the richer color sense that has since evolved.

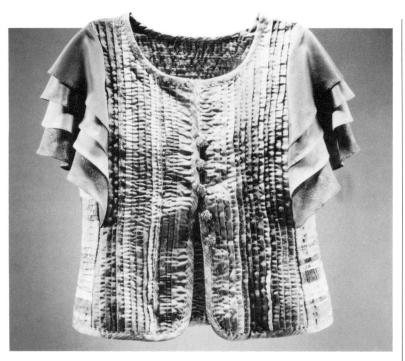

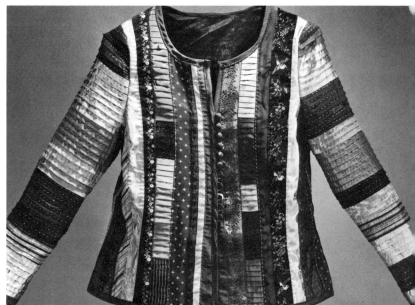

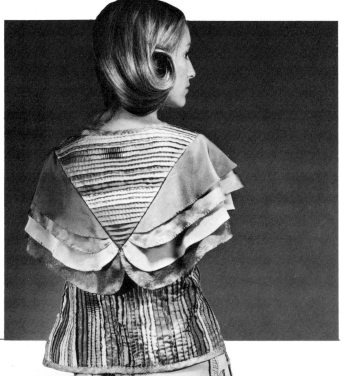

One piece may be primarily light, another primarily dark, but it is rare for any of São's pieces to mix light and dark in equal measure. In two ruffled and pleated jackets (see also plates 9 and 10) the palest, most delicate shades of ivory, beige, and terra cotta flow gently one to the next, unified by both their light tones and brown-based hues. (Each ruffle on these two silk jackets is cut on the bias from a full circle of silk and hemmed with a basting stitch in metallic thread.) Similar colors are used in the striped jacket (see also plate 8), but here they have deepened to coffee, rust, and sienna, with a few highlights of peach and cream.

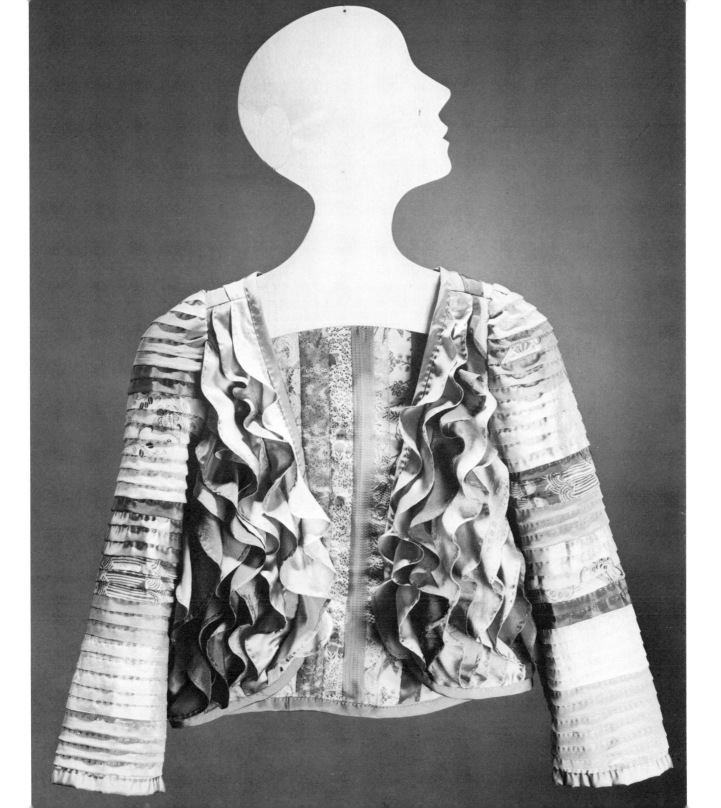

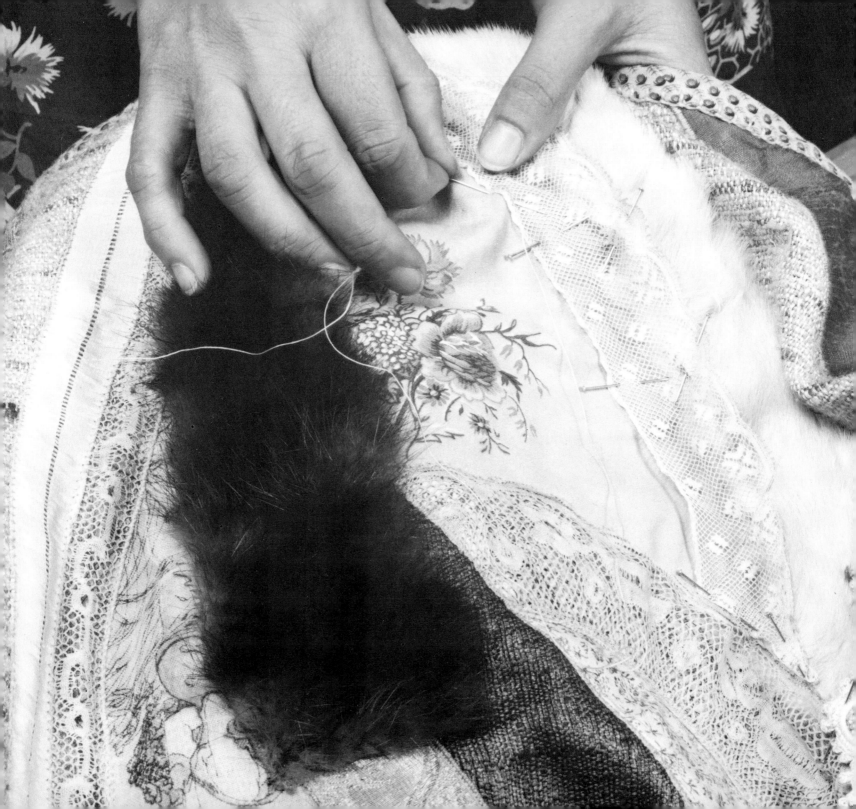

"I work with fine, soft lines and colors to portray a feeling of fluidity and lightness," says São. "But I use dark, more serious colors and formal lines to convey a certain protectiveness and inspire self-confidence. At present I work primarily with subtle colors, whether light and delicate or dark and dramatic, from black, gray, charcoal to wine, earth, and honey. One shade leads me to use another and to consider other possibilities. It is amazing to see how opposite colors can work together once intermediary shades have been added to balance and unify them."

At first glance one may be struck primarily by the complex colors of the pieces, but on second look the variations in their texture become equally intriguing. Unexpected juxtapositions of very different fabrics and techniques enrich the surfaces and create a multitude of effects. The ivory-colored vest (see also plate 23), for example, though classically simple in its cut, is made sumptuous—even medieval—by the combination of silks, laces, petit point, antique ribbons, and furs, all of which are hand appliquéd on handwoven raw silk.

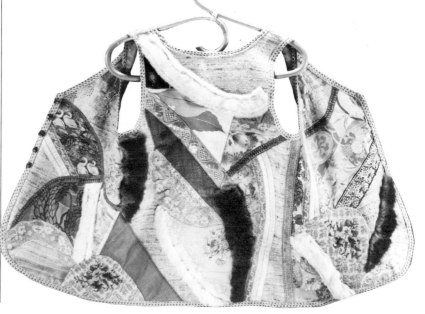

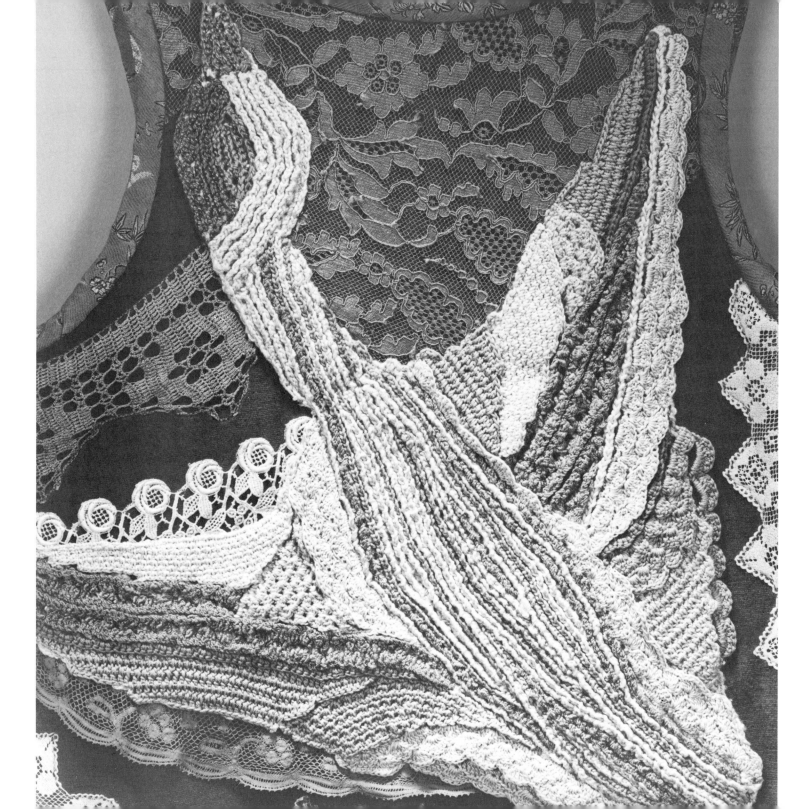

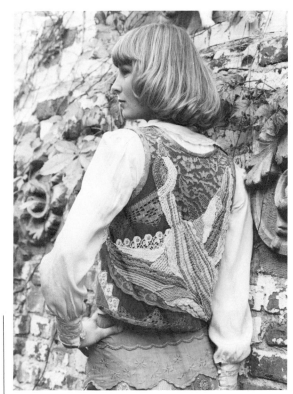

Against the courtly fineness of the ivory-colored vest, another vest and its matching skirt (see also plate 21) display an almost organic roughness. A birdlike form spreads its wings across the back of the vest, and the use of this image intensifies the autumnal effect of the earth- and pumpkin-colored fabrics. Crocheted separately, then appliquéd to the vest, this birdlike form is surrounded by tinted laces that integrate it into the overall pattern.

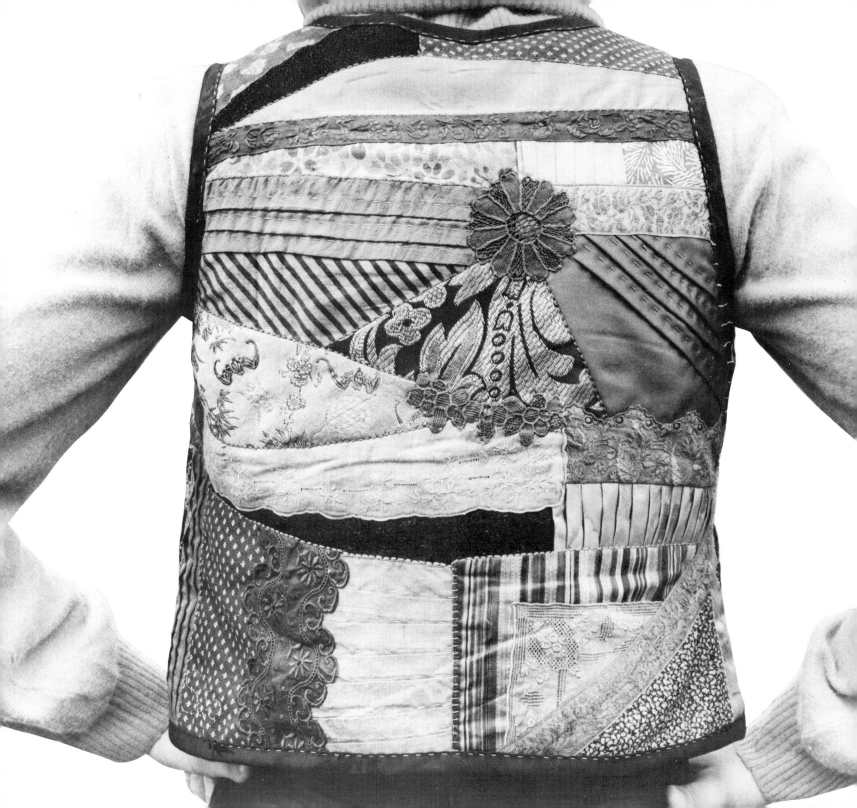

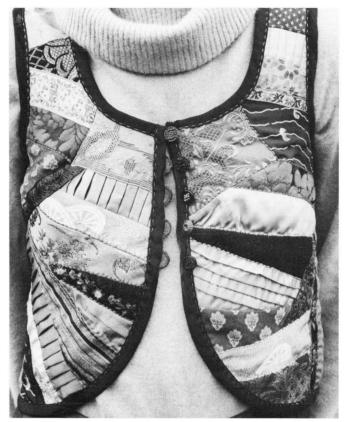

In yet another vest (see also plate 5) the textural variety of silks, satins, brocades, cottons, and laces is heightened by the use of appliqué, pleats, and embroidery to add another dimension of textural detail. Hard-edged pleats cast shadows in constantly changing patterns, while the tiny embroidery stitches in both cotton floss and metallic threads sparkle with light as they emphasize the boundaries of the fabrics. Appliqués of lace and ribbon serve as both decorative and unifying elements, guiding the eye from one section to another as well as adding yet another layer of visual interest.

Pattern as an element in the work functions on two levels: the overall pattern of each piece and the juxtaposition of patterns within it. Most of the clothes are constructed in either a stripe or a "free-form" pattern, though the two types are often combined in a single work. The

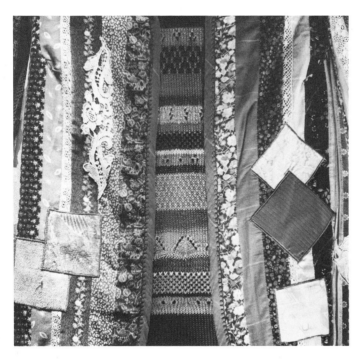
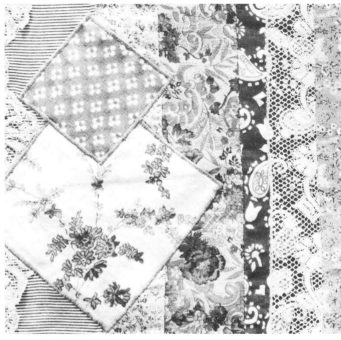

stripes might be row upon row of pleats, as in the ribbon and silk jacket (plate 8), with its crisp pleated sleeves and echoing panels of pleats in the body. Stripes can also be fluid and three dimensional, as in the ruffled and pleated jacket (plate 10) where the wavelike ruffles lap against the pleat-striped sleeves. In the striped velvet jacket (this page and plate 6) the outer vertical stripes intersect with the horizontal lining, and appliquéd squares underscore the geometry.

The free-form pieces are generally more curvilinear, composed of free-floating shapes that have, of course, been painstakingly plotted. Both the ivory fur-trimmed vest (plate 23) and the dusky vest with pleats and embroidery (plate 5) demonstrate the potential for variety within this structure.

In constructing either a striped or free-form piece, a great deal of thought must be given to the juxtaposition of individual fabrics.

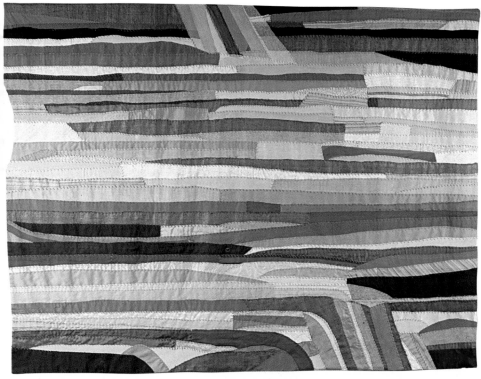

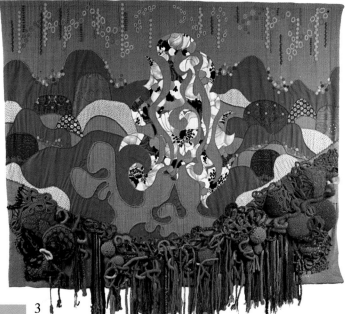

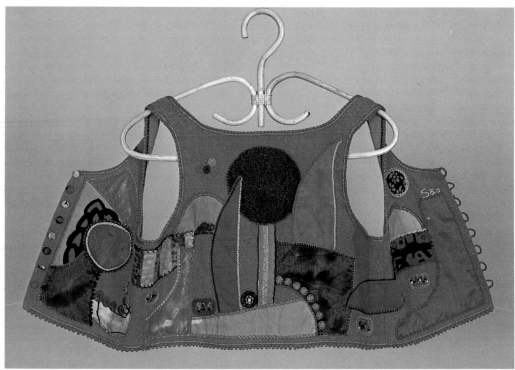

1

2

3

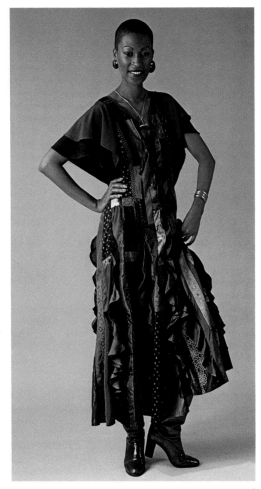

4

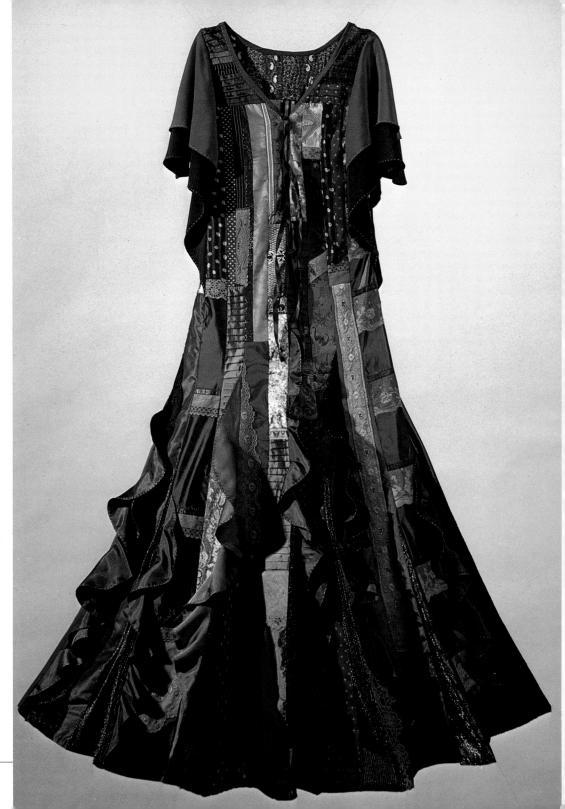

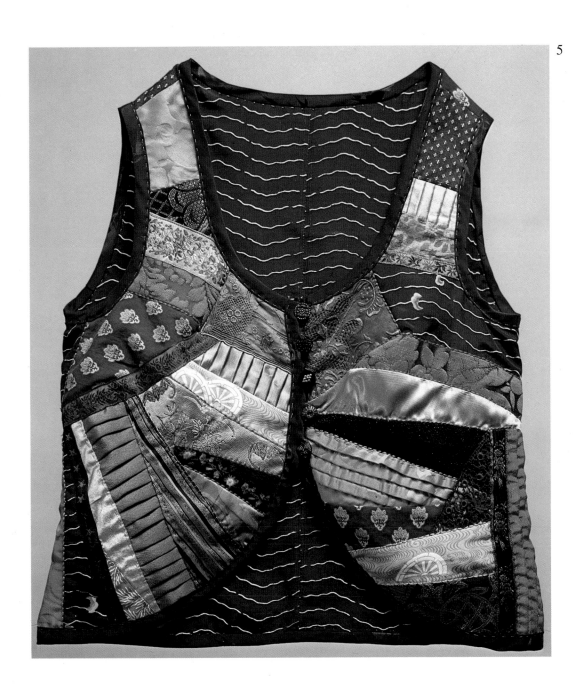

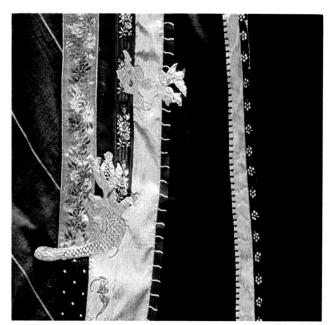

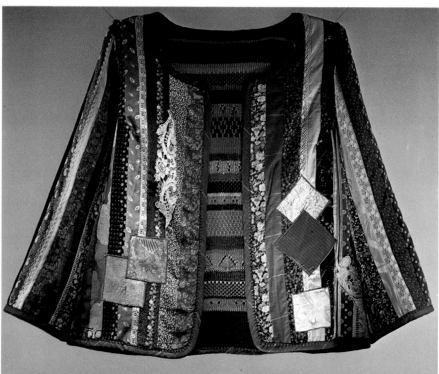
6

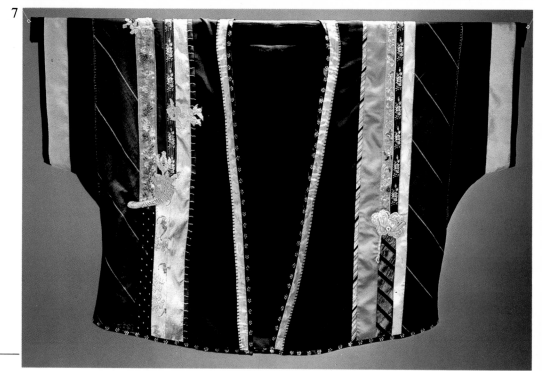
7

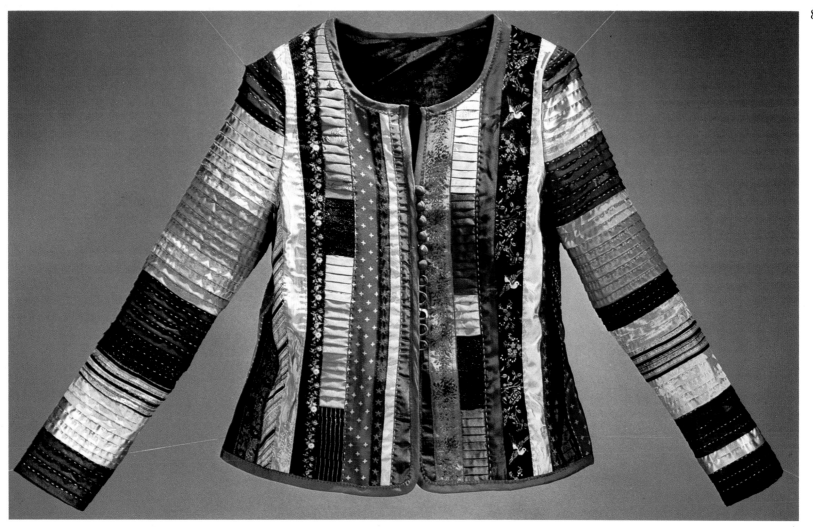

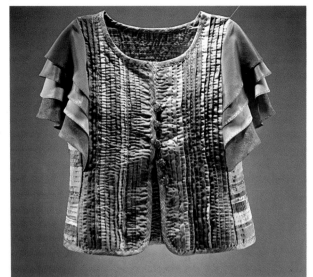

9

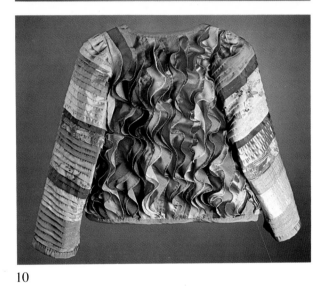

10

11

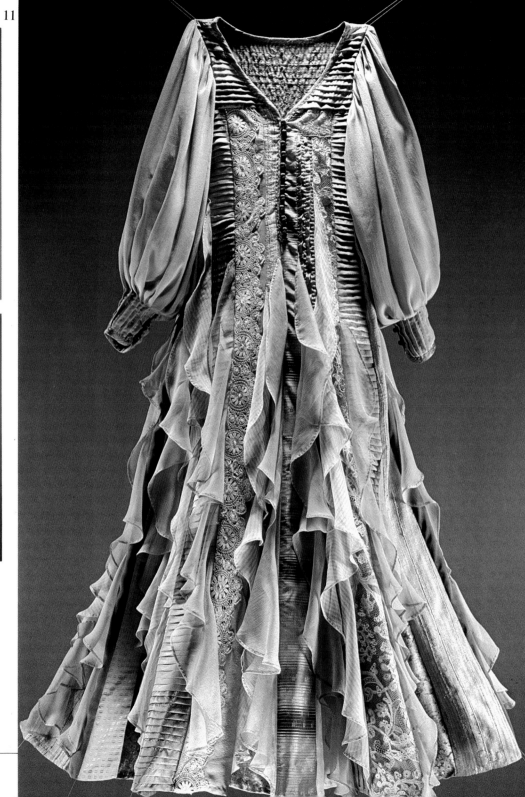

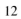

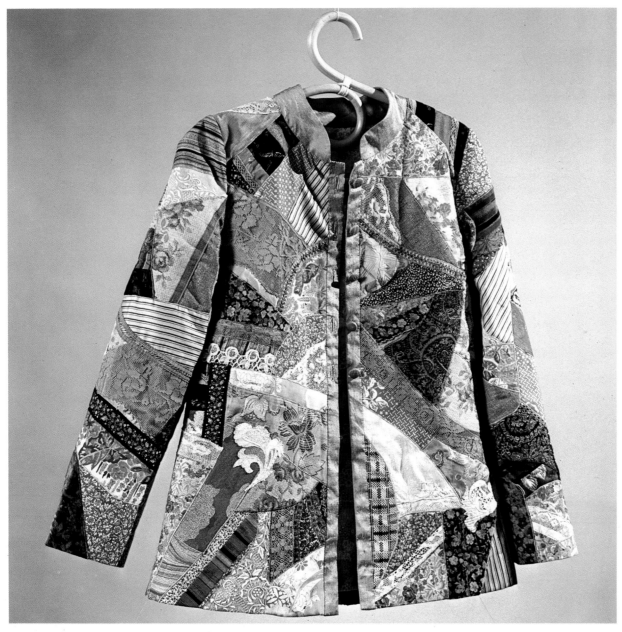

13

14

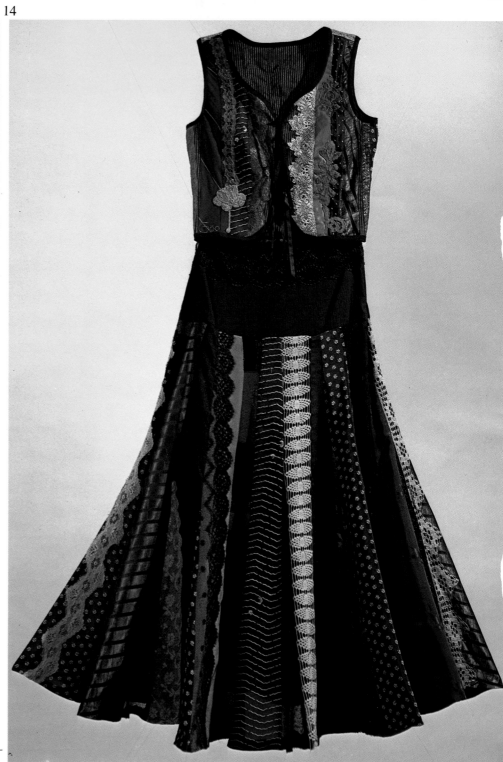

Occasionally a piece will be composed primarily of solids, in which case the emphasis will be on the interplay of color. (Even the "solids," however, are more often than not a tone-on-tone fabric, in which the subtle, almost subliminal pattern contributes to the overall richness.) Generally, several prints will be combined, and these must be carefully chosen, with an eye toward both harmony and contrast. There are no rigid rules to follow, but São's preferences frequently run to smaller motifs that add liveliness without overpowering the composition. Florals, geometrics, oriental fantasies, art deco delights—all can be used as long as they respond to each other gracefully. If the contrast between a print and solid seems too harsh, a piece of lace may be appliquéd over the border to ease the transition.

When experimenting with color, texture, and pattern, one soon develops a sense for what works and what doesn't. Although color combinations may be plotted with a color wheel and sure-fire systems can be devised for juxtaposing only certain prints and fabrics, one's own instincts are ultimately the best guide. To explore all possible variations on a favorite color, to capture a certain mood or emotion, and to combine materials in ways that express a personal design sense are undeniably more satisfying than to simply adopt someone else's combinations. And caution should be balanced with a little risk-taking—to be safe is to be boring.

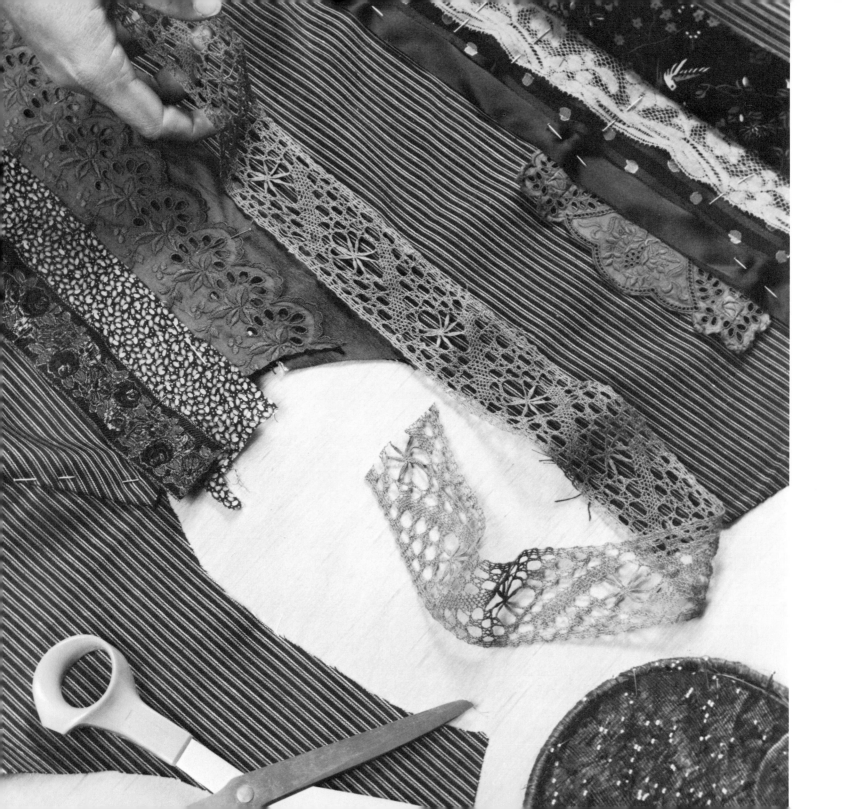

4. COLLAGE

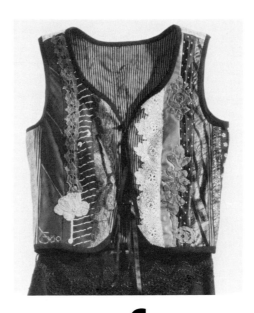

\intão applies the term "collage" to both her wall hangings and her clothes, using it to identify her abstract compositions regardless of the technique used to construct them. Most of her collages are primarily appliqué, though patchwork is occasionally incorporated and embroidered details are frequently used as highlights.

Appliqué means, simply, "put-on" or "applied": pieces of fabric are cut out and attached to a fabric base. Whereas in traditional collage the elements are pasted onto a wood, paper, or canvas support, São's appliquéd collages are generally stitched to a fabric base—usually a sturdy fabric, such as muslin, for the wall hangings, and a light gauze for the clothing. The edges of the individual elements may either be turned under before being stitched or left with the raw edge visible, depending on whether a smooth or rough effect is desired.

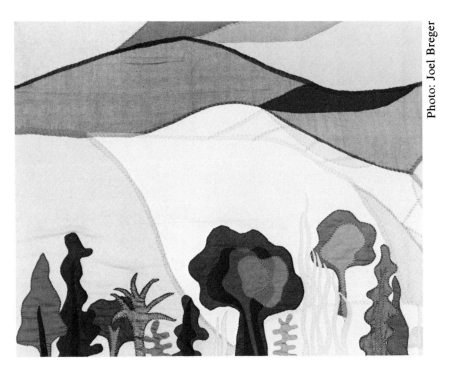

Photo: Joel Breger

In recent years, São's compositions have become predominantly abstract, though the presence and influence of nature are still vivid. In her appliqué wall hanging from the Nature Series, lively plantlike forms are superimposed on an abstracted landscape. The *Horizons* hanging (see also plate 1) is also entirely appliqué, but here no trace of flowers or foliage remains. One senses instead the structure of the land itself in the bold clay-colored bands that transverse the work. There is a suggestion of light beaming down at the top, a hint of a road or river curving off to the right down below. The fabric edges are intentionally raw, the stitches blunt and undisguised, the textures simple and rather rough.

Above: Nature Series II. *51 × 69 in. Silks hand appliquéd on cotton, edged with slant stitch in pearl cotton.*
Right: Detail of Horizons. *57 × 80 in. Cotton, silk, and net hand appliquéd on muslin, edged with slant stitch.*

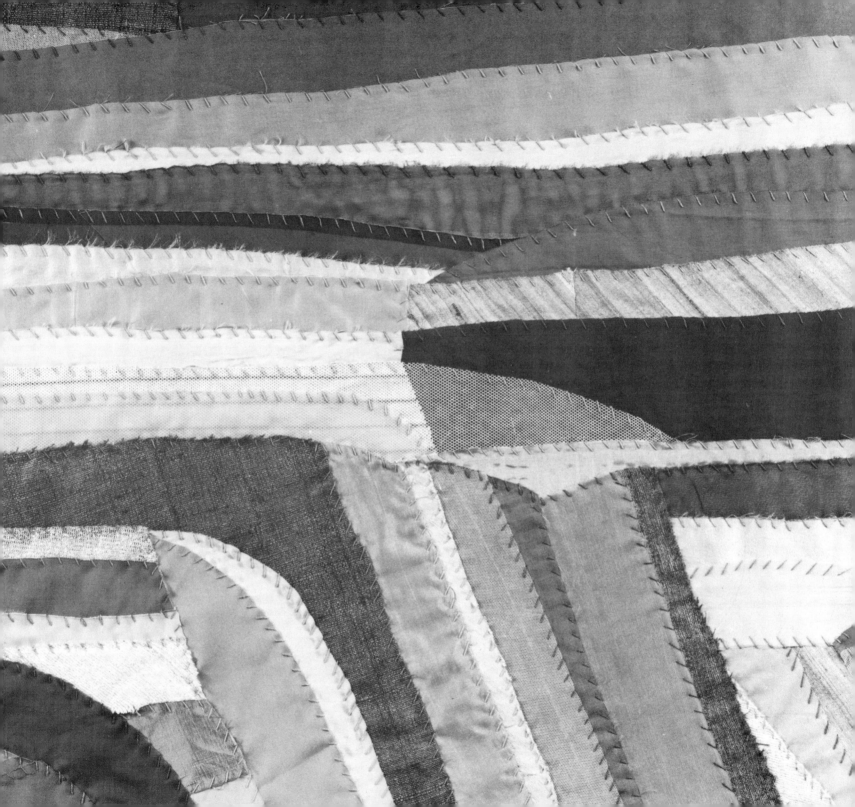

Any kind of fabric—thick or sheer, rough or shiny—can be used in collage. An overlap of two transparent pieces may produce a shadowy third color. The juxtaposition of fur, lace, satin, and pleats intensifies the distinctive tactile qualities of each one. Even the juxtaposition of the same basic fabric—silks, for instance, in different weights and textures—can be most effective.

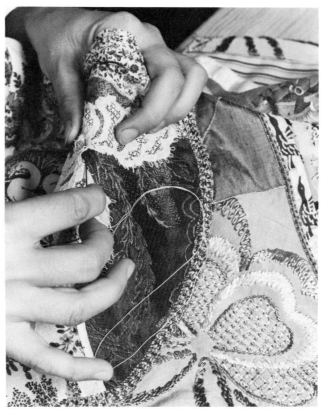

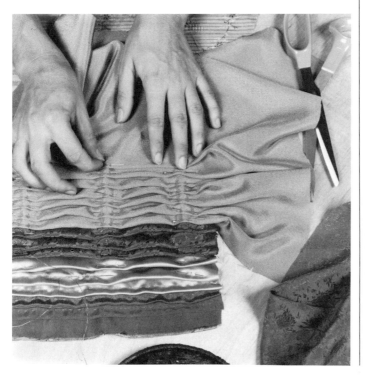

The stitching itself may be done in a variety of ways. Machine stitching may be used both to anchor a piece in place and to accentuate its edges. Blind hand stitching, which attaches a piece without showing, is often used to apply laces, ribbons, and other ornamental overlays. A variety of embroidery stitches may be used to add contrasts of texture and color.

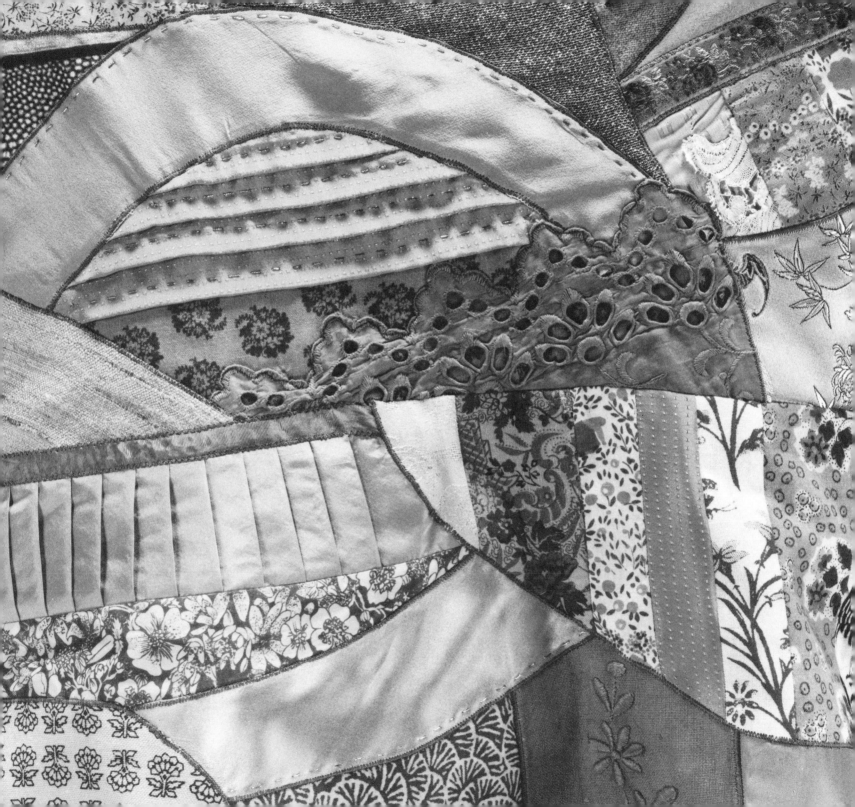

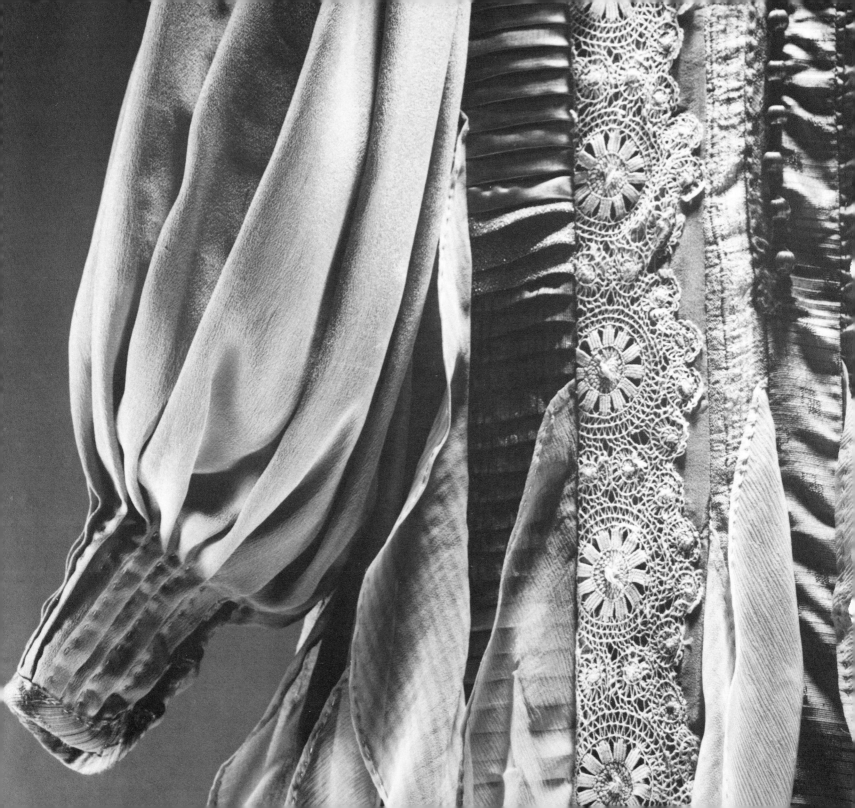

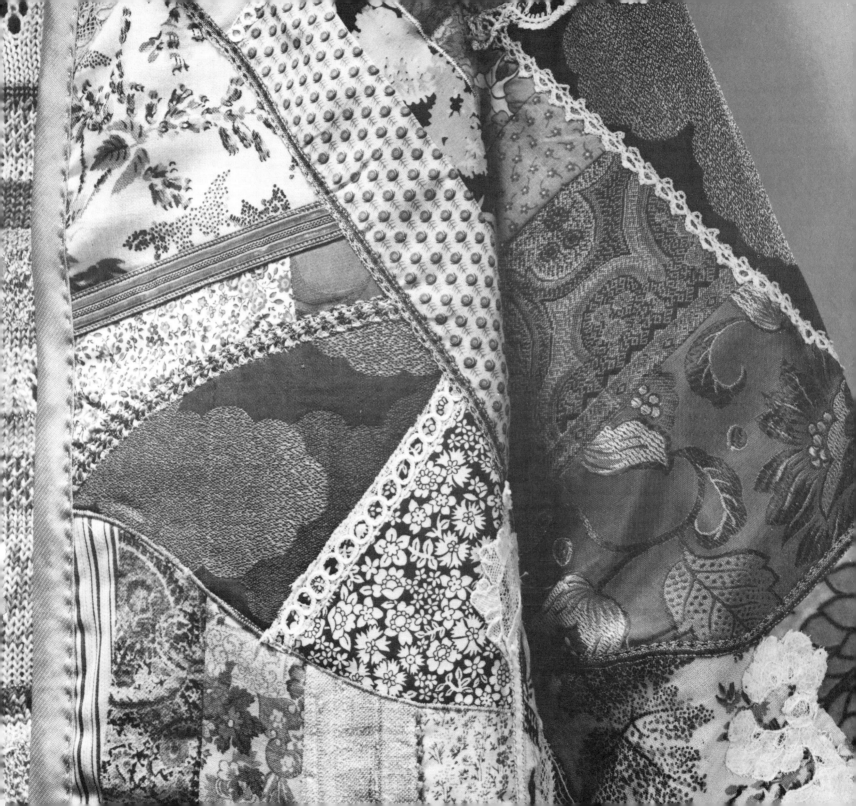

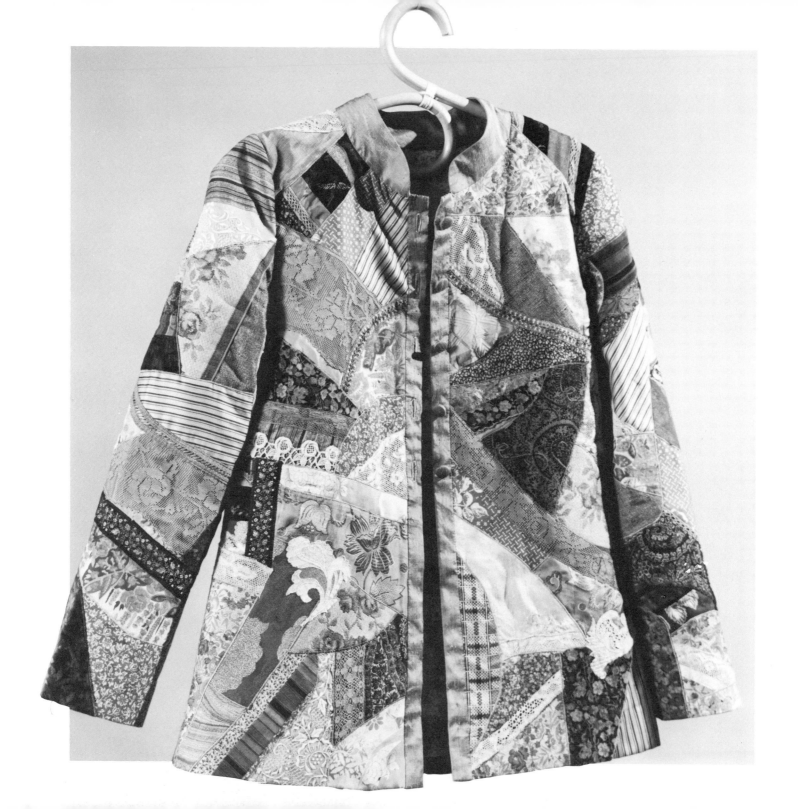

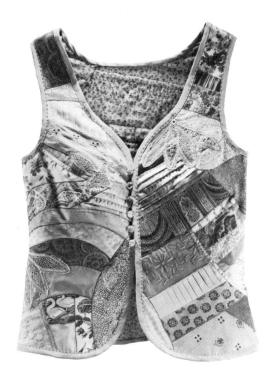

dizzying complexity. Others, like the buttonless vest, are resolved into simpler patterns—rows of stripes, perhaps, with only a few swirls of lace as counterpoints to the pure geometry.

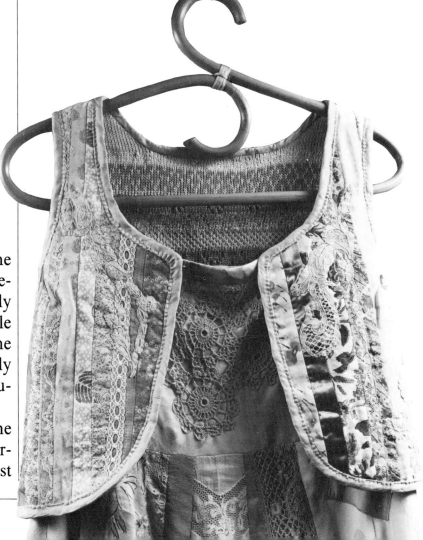

Although the fabrics are richer and the techniques more refined, the forms of São's elegant collage vest (see also plate 22) are clearly related to the landscapes of her hangings. While suggesting the land these shapes also echo the body—in front, gently curving diagonals subtly emphasize the breasts; in back, a softly undulating "horizon" line marks the waist.

Some of São's appliquéd collages—like the jacket (left and plate 12)—are intricate overlapping, interlocking compositions of almost

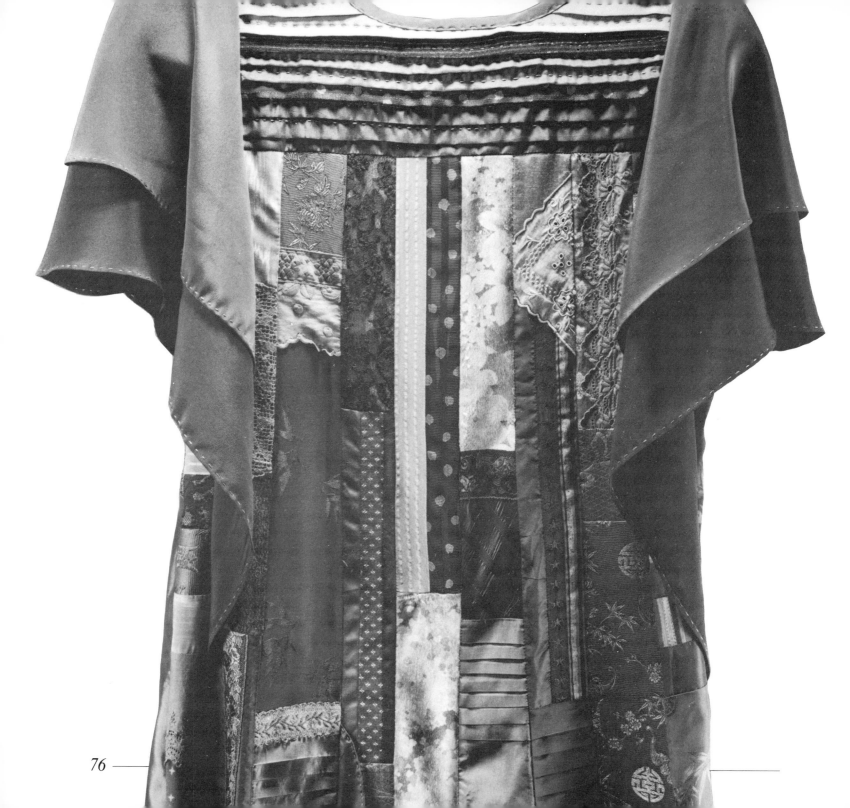

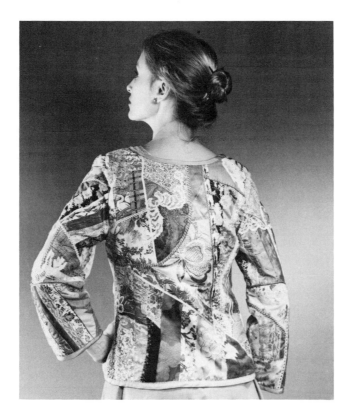

In patchwork the individual elements are sewn not to a separate support but to each other—a technique better suited to joining straight edges than complicated curves. The pieces are usually machine stitched together on the wrong side, which gives a strong, unobtrusive seam that may or may not be overstitched by hand. Patchwork can be used alone to construct a variety of clothing and accessories, but more often São combines it with appliqué and embroidery (see also plates 4 and 18).

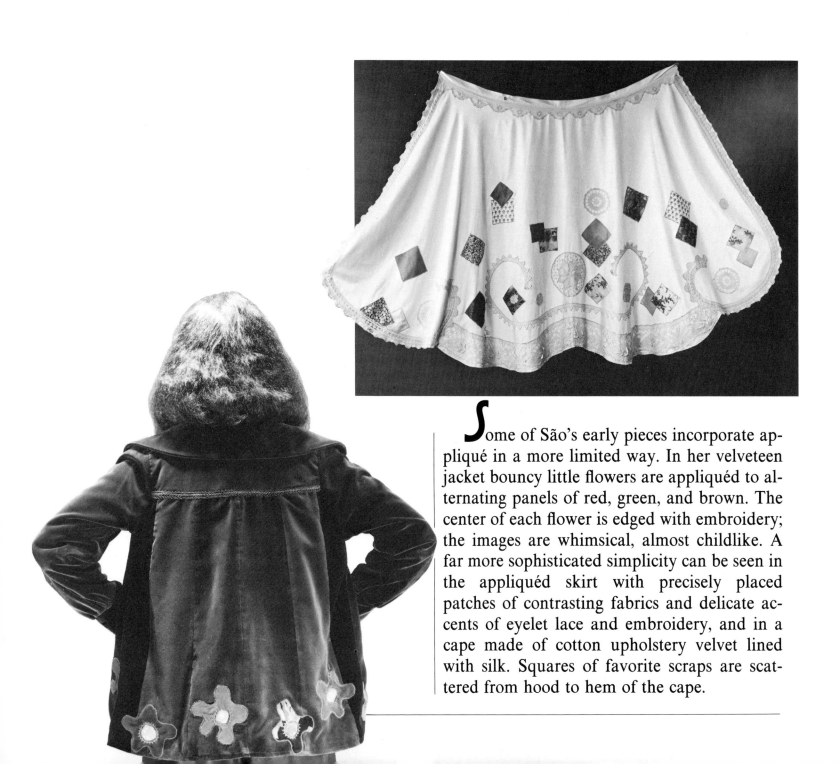

Some of São's early pieces incorporate appliqué in a more limited way. In her velveteen jacket bouncy little flowers are appliquéd to alternating panels of red, green, and brown. The center of each flower is edged with embroidery; the images are whimsical, almost childlike. A far more sophisticated simplicity can be seen in the appliquéd skirt with precisely placed patches of contrasting fabrics and delicate accents of eyelet lace and embroidery, and in a cape made of cotton upholstery velvet lined with silk. Squares of favorite scraps are scattered from hood to hem of the cape.

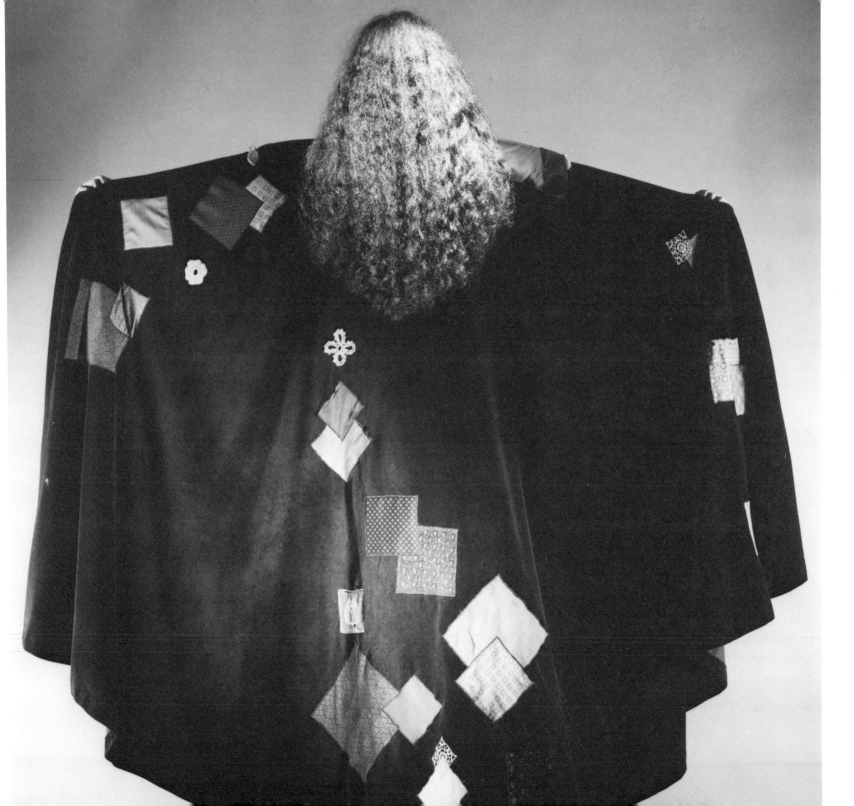

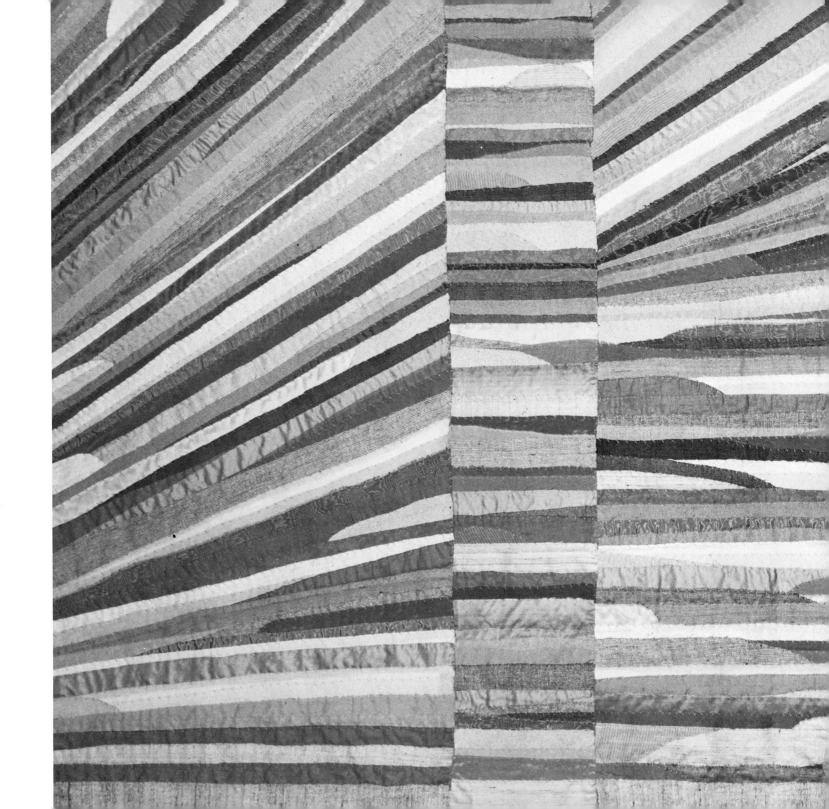

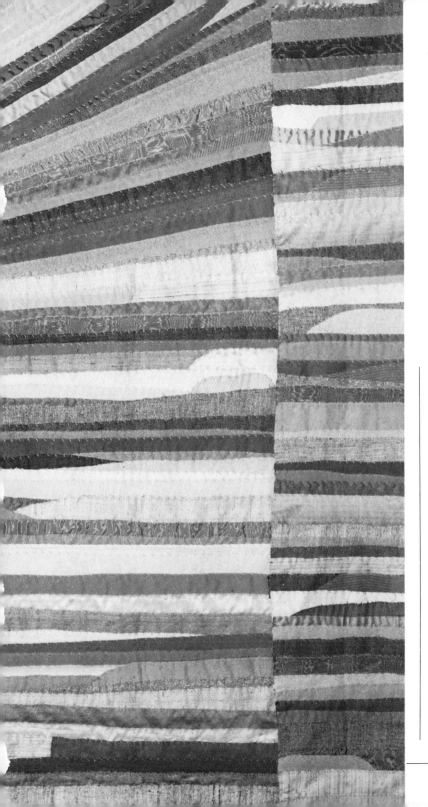

Scapes I. 75 × 115 in.

São says: "Most of the clothes and wall pieces I am doing at the present time derive from different uses of fabric strips, and I feel I have not yet exhausted the possibilities of this technique. Landscapes were my inspiration for a long period of time; everything was composed with a landscape in mind. Many of my latest hangings, using the strip idea, are landscapes. If an idea seems to work, I don't abandon it, because I have found that through repeated use of strips in different ways, both the techniques and the composition are improved. "My collages are based on the same principles, but here I don't have to think about straight seams and perfect lines. For me collages are great fun; I love the freedom of playing with bits and pieces of fabrics. They add tremendously to the liveliness of a composition."

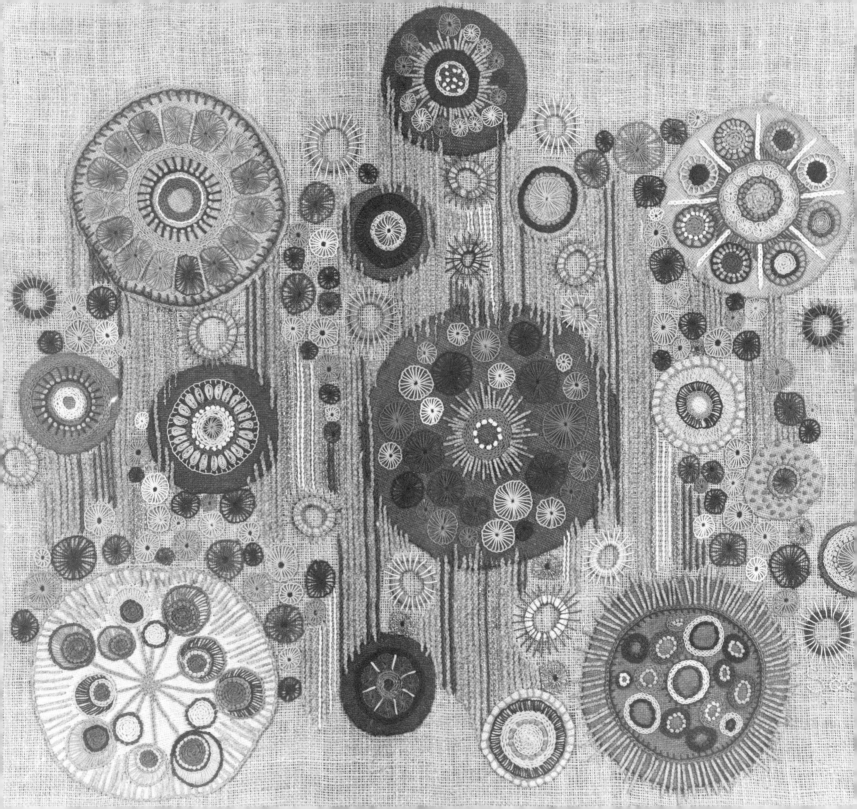

5. EMBROIDERY

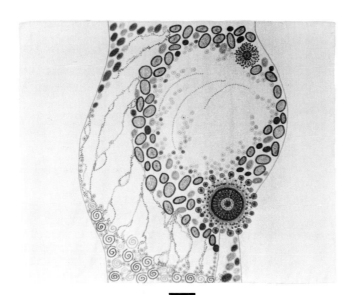

Photo: John Tennant

For São, embroidery means "treasures," and this love for the rich variety of stitches and threads is evident from her earliest work to the most recent.

Once the knowledge she acquired in Portugal was coupled with the imaginative freedom she developed in Denmark, São was able to explore embroidery in many new ways. In *Flower Explosion*, an early wall hanging that she made in Denmark, the bright spinning circles radiate energy, suggesting a windblown overgrown garden or clockworks gone mad. Running stitch and wheel stitch; buttonhole, blanket, satin, and chain stitches; French knots and petal stitches—all intertwine in a tangle of shapes, textures, and colors.

In a more recent wall hanging, *Life Torso*, a similar profusion of stitches creates a far different effect. The pregnant torso is delicately stitched, suggesting the quivering life it contains.

Left: Flower Explosion. *34 × 38 in. Burlap appliquéd on burlap, with crocheted rings and embroidery in all types of stitches and threads.*
Above: Life Torso. *34 × 38 in. Embroidery and beads on linen.*

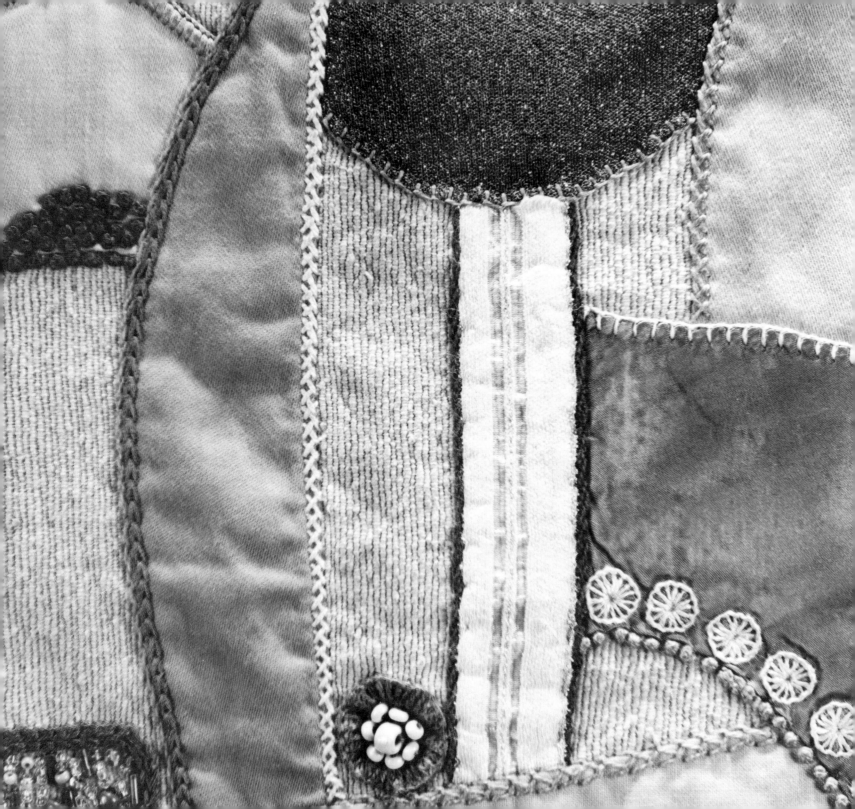

The same stitches that create such diverse atmospheres in the wall hangings also serve purely decorative purposes in the wearable art. An already bold and lively vest (detail, left, and plate 3) is made even more striking by the embroidery that edges the appliqués with hotly contrasting colors and that anchors down multi-hued piles of beads. French knots,

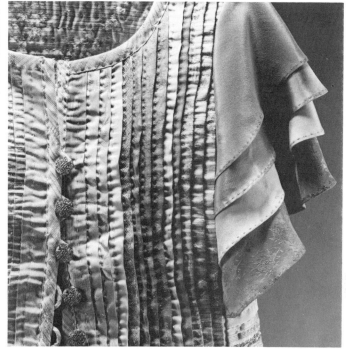

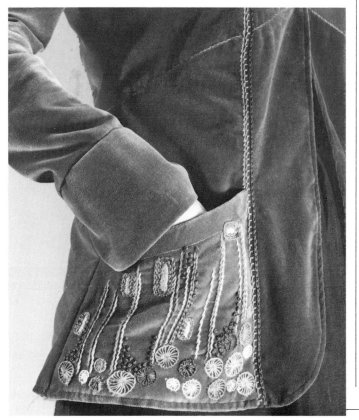

wheels, and buttonhole, chain, running, cross, feather, and back stitches are used in this section of the orange and violet vest. Embroidery emphasizes the seams and decorates the pockets of a velvet jacket, and a simple basting stitch in metallic thread hems the sleeves and holds down the pleats of a sumptuous silk jacket (see also plate 9).

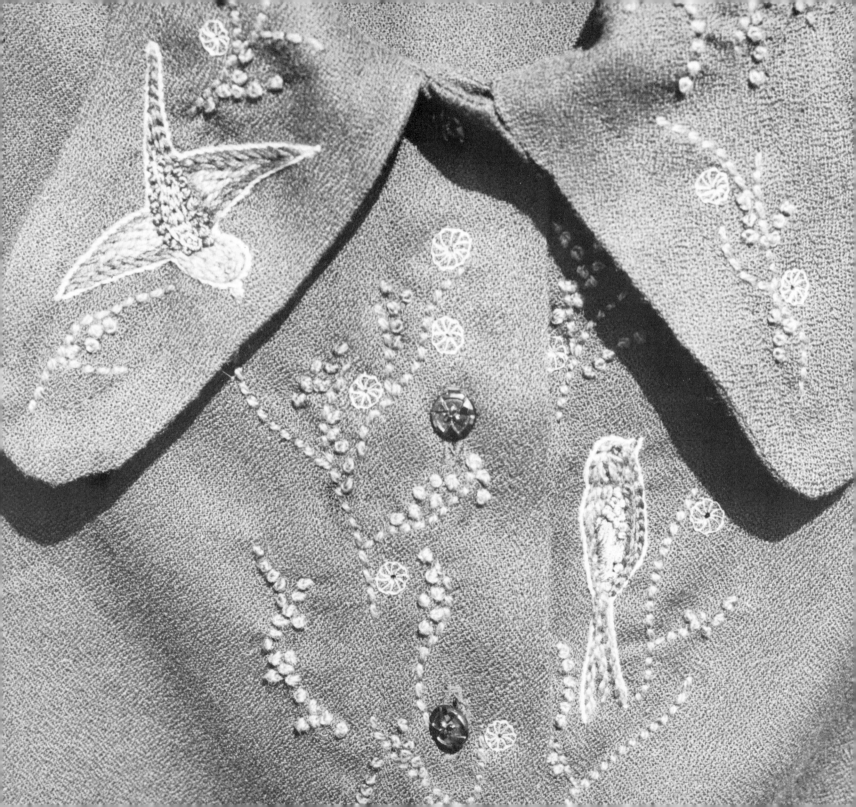

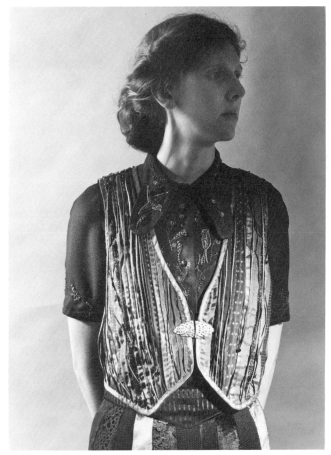

Embroidery can change the entire personality of *any* piece of clothing. A simple black wool crepe blouse was embroidered on the collar, along the front, and on the edge of the sleeves with motifs that were designed free hand, then stitched with cotton floss, pearl cotton, and metallic thread. The branches were sewn with flat stitches; the flowers with French knots and looped wheels; the birds with knots, stem, running, flat, and chain stitches. The original buttons were replaced with smaller ones made of glass. Quite a transformation! To go with the embroidered blouse, São made a vest from pleated strips of silks in various widths and colors, sewn down to a silk base with flat basting stitches that show on both sides. After the pleats were finished, silk cords were added (some were sewn to the bias strip at the edges, others attached with small glass buttons) to give a more three-dimensional effect.

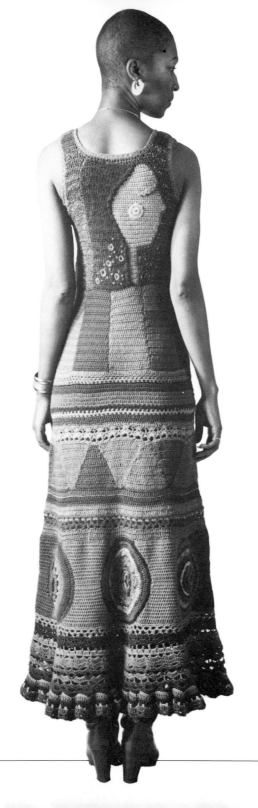

In addition to cloth, knit and crochet can also be embroidered. In a long wool dress, a smiling face (on the front) and a profile (on the back) are fashioned from simple stitches—French knots, wheels, and satin—applied directly to the hand-crocheted bodice. Intricately striped vests and sweaters can also be enlivened with hand embroidery—wheels and flowers are only two of the design possibilities.

Embroidery patterns can be discovered everywhere—not only in ready-to-stamp transfers and craft-book diagrams, but also in a favorite printed fabric, an antique French ball gown, a child's drawing, a Persian rug, a scrap of oriental brocade. Books, magazines, museums, nature itself, are all likely sources of unusual patterns. Embroidery is appealing in part because it is so versatile—it can be purely linear, using a running, stem, back, or chain stitch to outline a form, or it can suggest an illusion of depth and modeling, using satin and other stitches to fill in and shade a shape. Stitches such as French knots, lazy daisy, herringbone, and buttonhole can provide pattern and texture, pleasing to both hand and eye. From time to time São consults a book of embroidery stitches: "Each time I do," she notes, "I discover another stitch that I had never seen before. I try

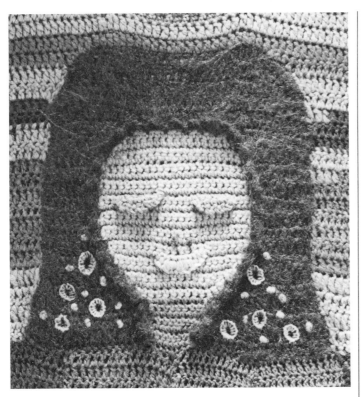

brightly colored cotton and exuberant floral and animal motifs to create a "funky" peasant effect; or, for a more sophisticated look, they could be embroidered with art deco geometric designs in silks and metallics, with a few appliquéd squares of satin thrown in for good measure. While it is always safe to match fibers—linen on linen, silk on silk, wool on wool—often a contrast is more interesting: silk on linen, metallic on wool, linen on silk. Cotton

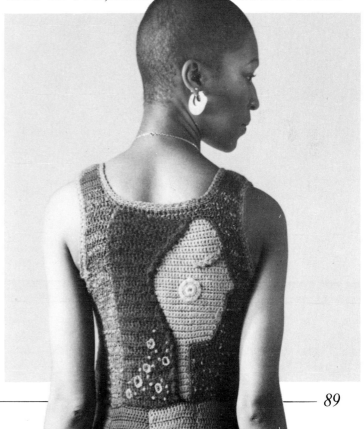

it and it is usually similar to others I have used, but never exactly the same. And sometimes I simply invent a new stitch just by experimenting."

The decision as to what kind of thread to use—silk, cotton, floss, pearl cotton, linen, metallic, or wool—depends of course on the base fabric and on personal preference. A pair of jeans, for example, could be stitched with

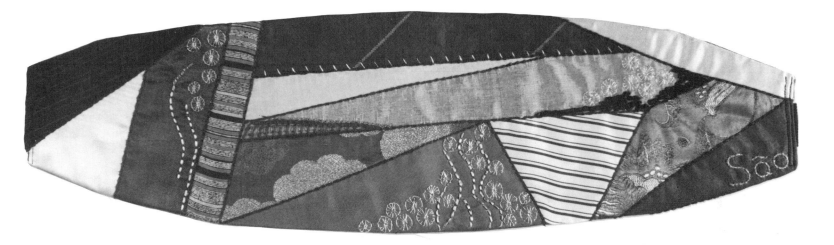

threads of various textures combined with linen on a nubby fabric will produce a pleasingly homespun, "rustic" look. A delicate cotton monogram on a simple silk or cotton shirt will add a classic elegance to it. Shiny silk and metallic fibers on a collage of silk, satin, and velvet will create a sumptuous richness. When faced with such choices, São suggests, "go for all of them!"

When simply outlining an appliqué or a seam (here, a simple backstitch worked in a pearl cotton outlines a strip of fabric), the shape of the embroidery is of course predetermined, and no preliminary sketch is necessary. But for something like the elegant bow tie and cummerbund, where the embroidery forms an independent pattern, a quick sketch on a separate

piece of paper can be used as a guide. (The reversible cummerbund and bow tie of silk, cotton, satin, and brocade are embroidered with metallic wheels and silk curves.) The more timid might prefer to draw their designs (with pencil or seamstress chalk) or to baste them directly onto the fabric and follow them faithfully, but while this method may help to prevent mistakes, it can also squelch any last-minute inventiveness.

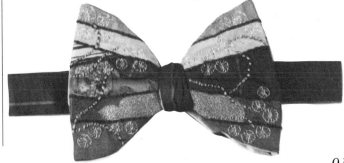

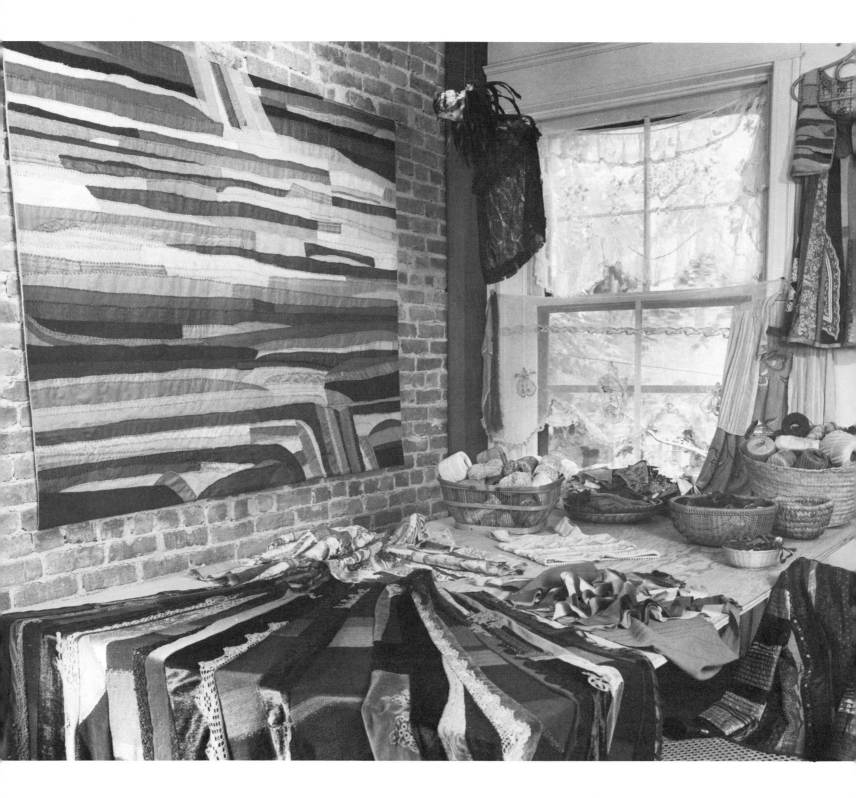

6. KNITTING AND CROCHET

Long before Madame Defarge and her blood-thirsty cronies sat knitting by the guillotine, people had learned how to manipulate two sticks and a thread in order to produce fabric. Knitting is, in fact, one of the oldest crafts—its origins barely discernible in the ancient Near East. By Cleopatra's day knitting had become popular in Egypt (scraps of knitted garments, including wool socks, have been found in tombs from the pharaonic and Coptic periods) and was well on its way to Europe.

In the Middle Ages a young man who wished to join the Knitters' Guild—and only young men were eligible, for knitting was a jealously guarded male province—had to spend three years as an apprentice, plus another three traveling to study foreign techniques and patterns. Even then, he still had to pass a rigorous practical examination before qualifying as a Master Knitter. Once having achieved this lofty status, he was likely to be patronized by kings and noblemen, for the skill was highly valued and every court had its favorite knitters.

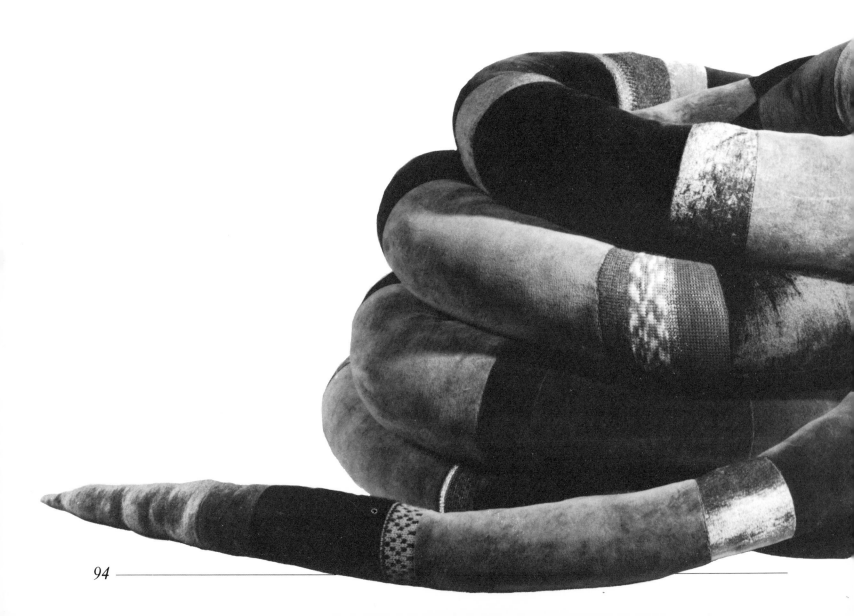

Elizabeth I was the first woman in England to wear knitted silk stockings—a Spanish innovation—and she swore she'd never wear cloth stockings again (an endorsement the Spaniards must have appreciated, since they pretty much kept the market cornered until the French took over in the 1700s). Though silk stockings are now as wistfully remembered as lace teddies and blue satin garters, knitting has continued in popularity to this day. Its popularity derives in large part from its simplicity and diversity; once the basics are mastered, one's imagination can run riot.

Some of São's most wildly inventive pieces have featured either knitting or crochet. Among the wildest are her snakes (see also plate 16)—soft sculptures that double as wonderfully inviting chairs. Reaching lengths of up to forty feet, they can be coiled into whatever configuration is the most comfortable for sitting or sprawling.

The snakes can be totally machine knit, or velour panels can be incorporated in them. The eyes and noses are embroidered; the tongue is a copper wire wrapped with yarn then spiralled around a pencil. The snake on this page combines velour panels with stripes of stockinette stitch, in both wool and metallic yarns. It is stuffed with polyester fiber (forty bags of it were required for this fellow).

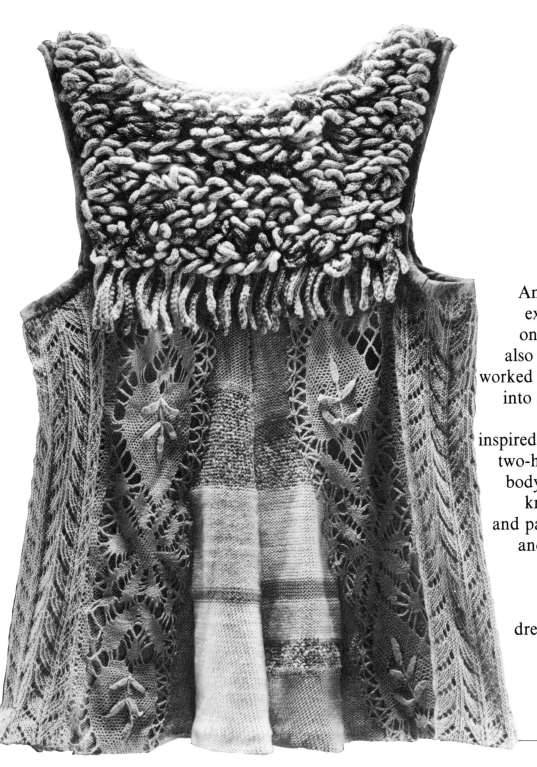

Another prime example of São's experimentation are the loops on the yoke of her lacy vest (see also plate 15). Actually little tubes worked individually and then hooked into the base at irregular intervals, these loops were the result of inspired fiddling, and took about four two-hour sessions to complete. The body of the vest is a patchwork of knit panels of contrasting fibers and patterns, hand stitched together and appliquéd with bobbin lace.

Knits can also be classically simple, as in the sweaters, dress, and skirt (opposite), where rich autumnal colors and carefully proportioned stripes combine in a beautifully balanced effect.

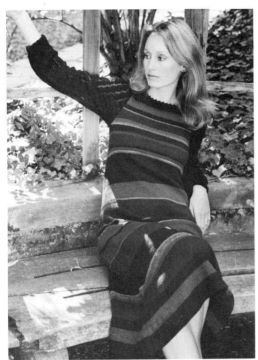

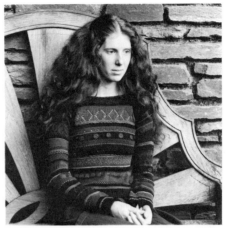

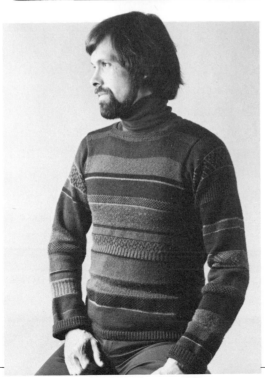

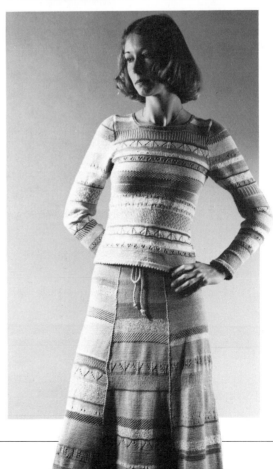

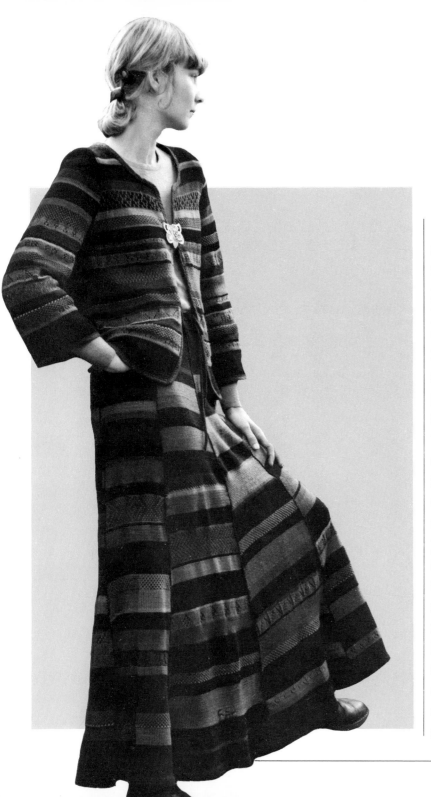

Whether knit by hand or machine, a striped panel skirt such as the one seen at left is relatively simple to make. Each of the six panels is knit in plain stockinette stitch. The panels are identical, except for the arrangement of stripes. Compatible colors should be chosen for the stripes, and the design can either be sketched out in advance or worked out as it goes along. Beginning at the waist, thirty stitches are cast on for each panel, and every ten rows one stitch is added to each side; this is continued until the desired length is reached—in this case, 400 rows. The six panels are then crocheted together on the right side, using a single crochet stitch worked in one of the same yarns used in the skirt. Before the final seam is sewn—while the skirt is still a long panel rather than a circle—the waistband is added. All the stitches along the top are picked up onto one needle, then six rows of stockinette stitch are knitted. In the seventh row, every tenth stitch should be transferred directly, not knitted, from one needle to the other. After another six rows of straight stockinette, the pattern of the seventh row should be repeated, then one last set

of six stockinette rows added, and all the stitches cast off. The final side seam should be joined, and then the waistband should be folded over and stitched down by hand. The holes made by the transferred stitches will line

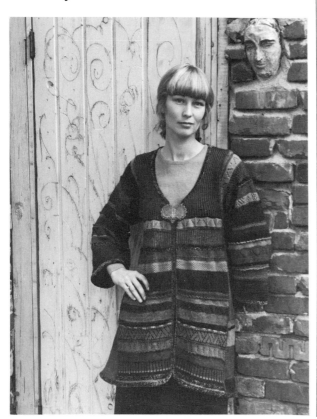

up, and a long knit cord (four stitches wide) should be threaded through the waistband, then pulled tight and tied. The bottom of the skirt is simply hemmed by hand. In all cases, the same yarns, whether wool or cotton, that were used in knitting the skirt should also be used in joining and hemming it.

The jacket seen with the skirt reverses to a fabric collage (see plate 6). Because knit has a tendency to stretch, the knit side was made first and the fabric cut exactly to fit it. Each side was sewn together separately, then they were attached together along all the outer edges (neck, front, and sleeves) with a bias strip cut from a fabric chosen to coordinate with the two sides. This strip was machine stitched onto the knit side, then folded over and hand-finished on the collage side. Either a plain hem stitch or a decorative embroidery stitch could be used for this final step.

Details in various techniques can be added as a counterpoint to the knitting; for example, the edges of the soft striped smock have been hand bound with a cotton velveteen print that echoes the earthy colors of the wools. Here, as

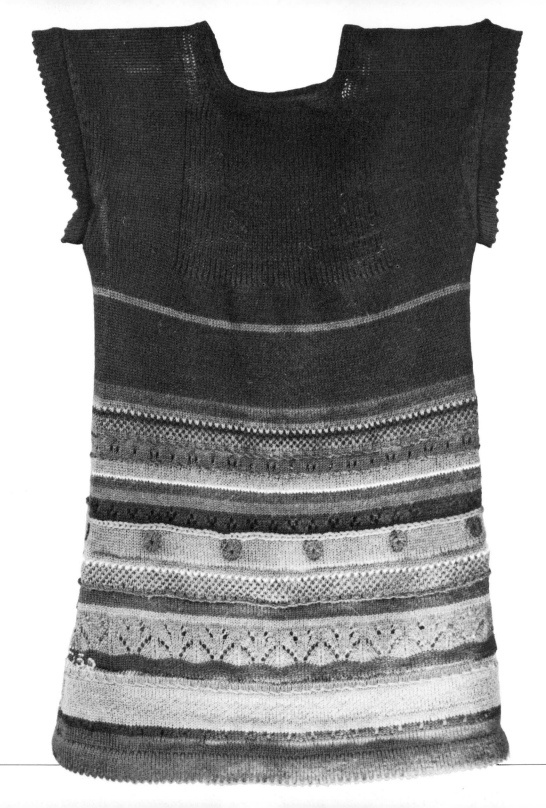

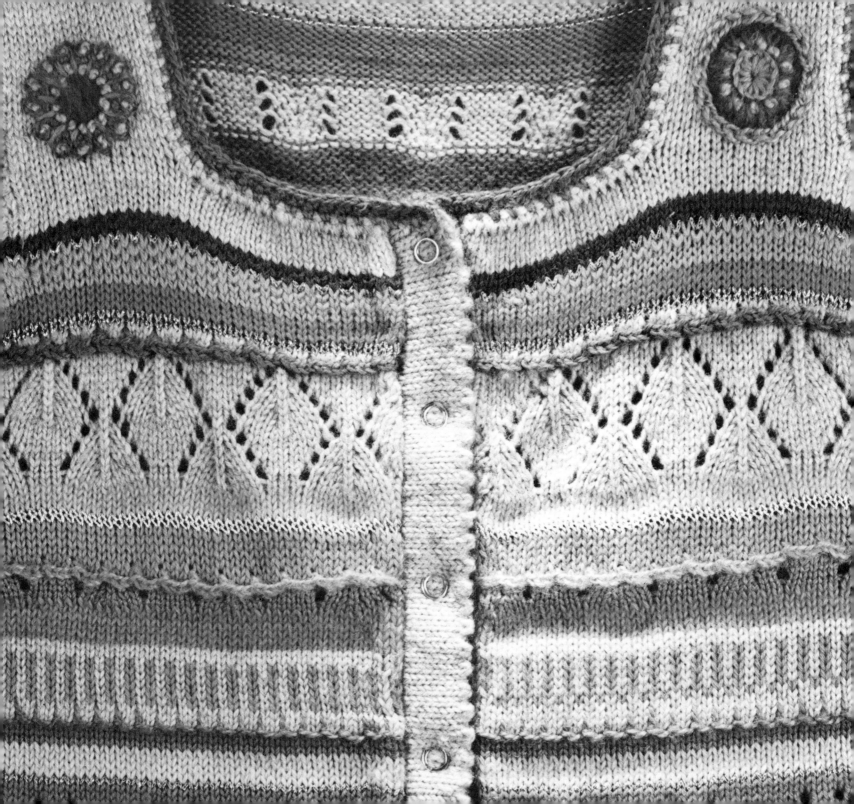

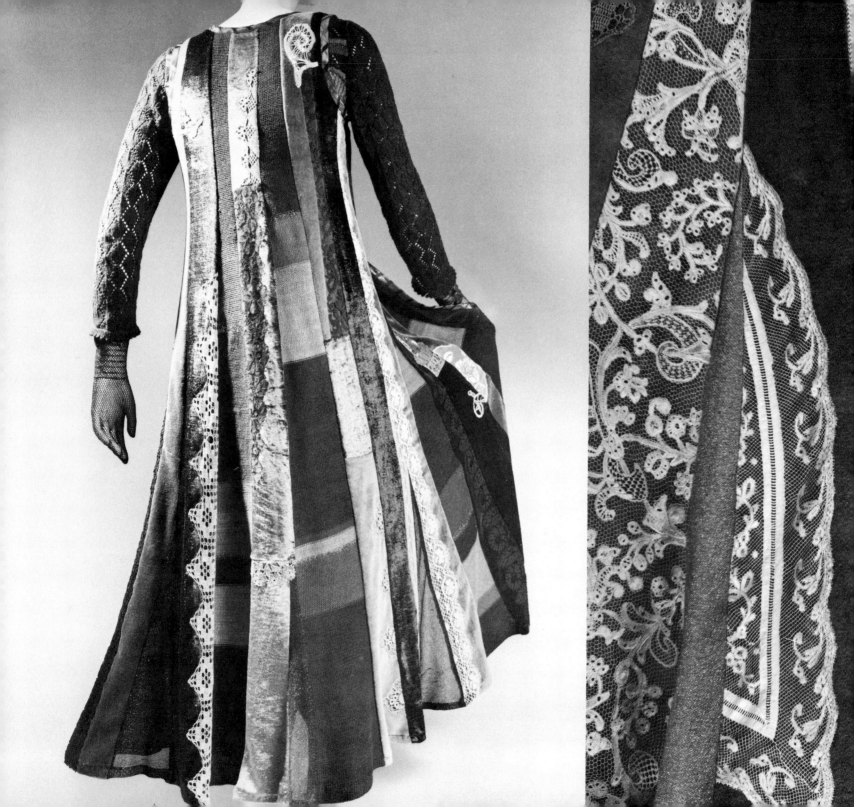

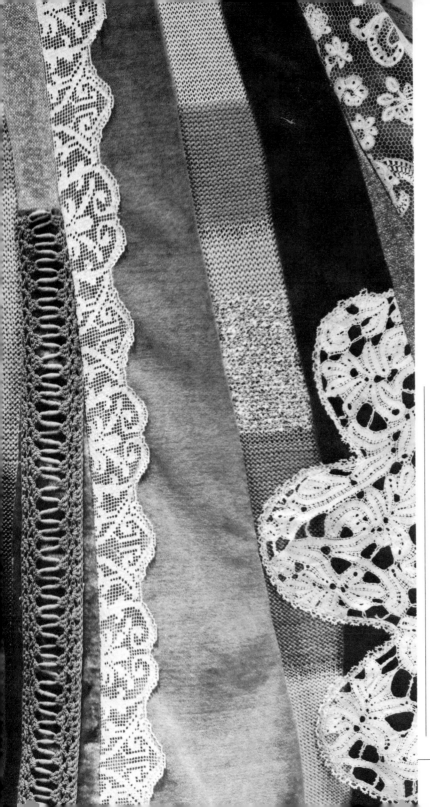

on the snakes, single rows of crochet are worked on top of the knit, providing either contrast or transition among the various stripes. The stitch most often used for this is a simple chain anchored after every few stitches with a single crochet into the knit base. In Denmark this is known as the "mouse jump" stitch. Embroidery can also be worked over the knit, as in the sleeveless smock, where wheels have been embroidered over the subtly colored stripes.

Knit itself can become a detail, functioning as one of many elements in a wearable collage. In the elegant long dress, panels of cotton, silk, and metallic threads machine knit in a nubby garter stitch interplay with glowing swatches of velvet, lamé, and brocade and with rich lengths of lace.

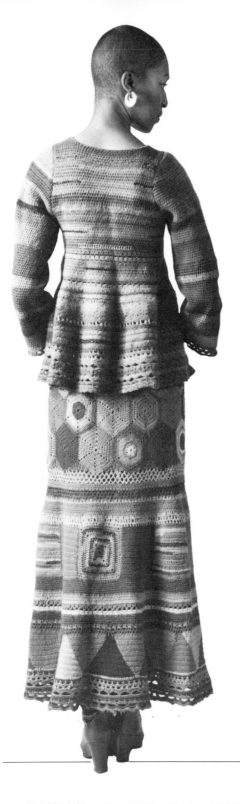

Crochet, even more than knit, seems to have inspired São to slightly mad flights of fancy. A crocheted skirt, composed of purely geometric shapes, vibrates with warmth and good humor. The squares, triangles, and trapezoids were crocheted as individual units, then stitched into bands; these in turn were joined together with multicolored rows of crochet in a variety of stitches: chain, plain single, plain double, and shell.

The bright clown face (on the sweater) grins out at the world, its eyes slyly circling the wearer's breasts. Eyes, nose, and grin were crocheted individually, following a full-size pattern, then they were crocheted together. The back and sleeves of the sweater were crocheted in a free-for-all of different stitches, using the same bright colors as the face.

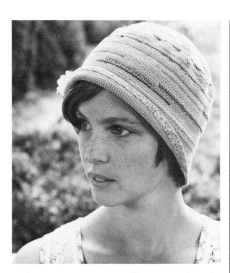

Similar ingenuity, on a smaller scale, is demonstrated by a seashell-toned cloche. Made entirely of single crochet tightly worked with a small hook, it relies on the subtle changes from silk to cotton to metallic fibers for its visual interest, with finishing touches supplied by a cotton print border and a floppy silk flower. The pinned-on flower could be replaced by a real-life counterpart, a feather, or an art deco pin.

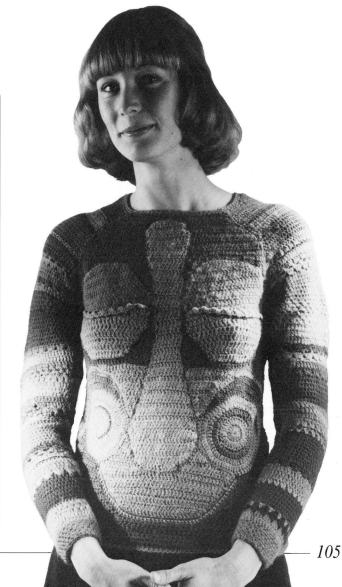

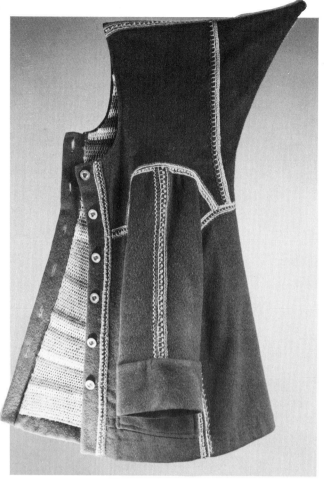

If knitting and crochet are among the most popular crafts, then mufflers must surely be among the most popular projects. Who has not made at least one muffler for a friend? Once started they are hard to stop—São's crocheted *tour de force* (opposite) rambles on for more than six feet, incorporating not only a myriad of different stitches, but knotted fringe and appliquéd beads as well. Mittens, though trickier, are another favorite project. The woolly pair seen here are single crocheted in asymmetrical stripes of rose and violet, then ruffled with a few rows of shell stitch. Muffler and mittens are fitting companions for a hooded jacket modeled after a Mongolian horseman's coat. Bright bands of blanket, chain, and other embroidery stitches edge the seams and emphasize the simple lines of the coat. The same bright colors blaze out from the lining, which is double crocheted with a rainbow of stripes. On a cold and dreary winter day the coat flashes with unexpected color, chasing the chill from both body and soul.

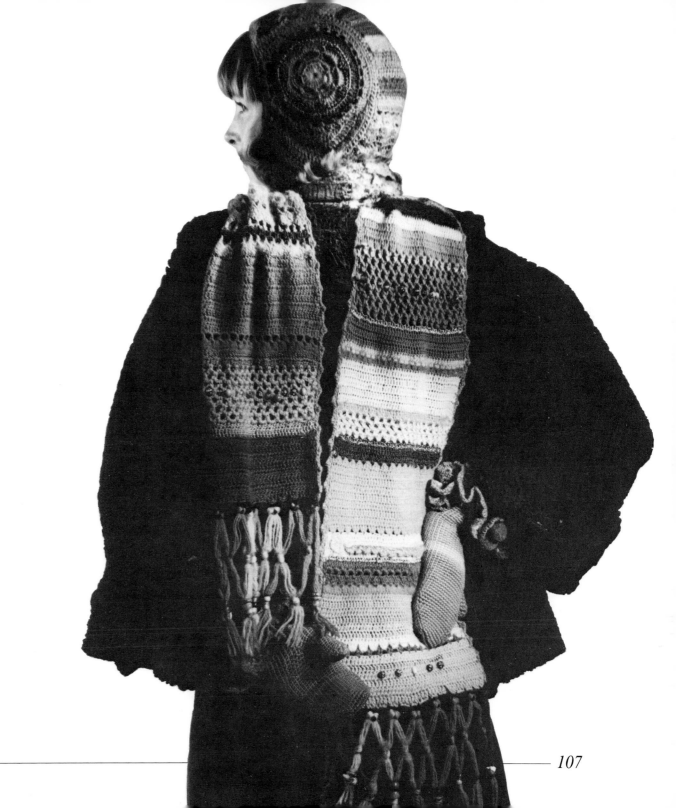

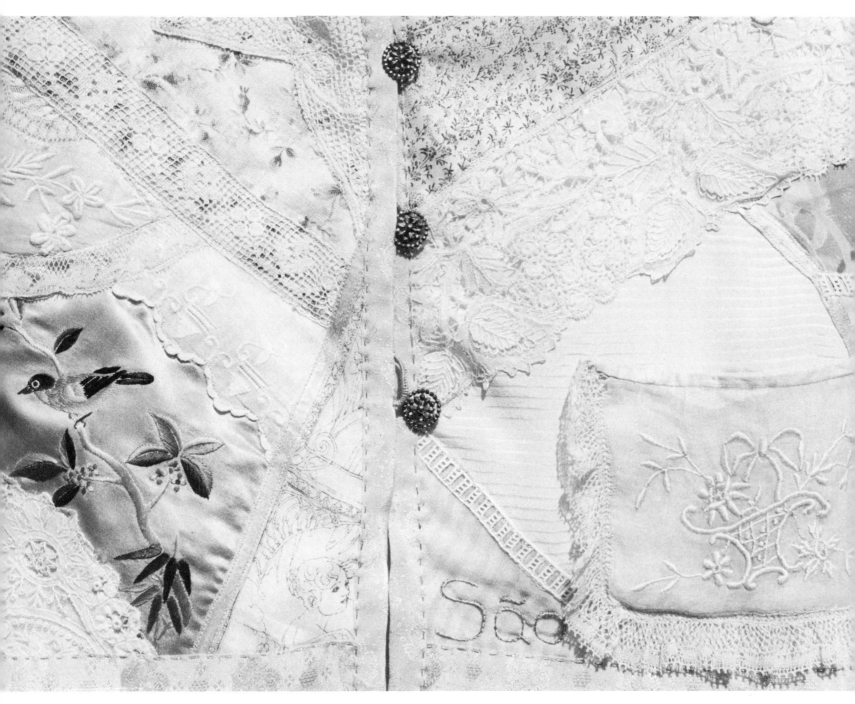

7. RECREATING

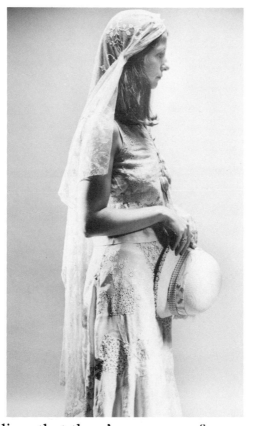

A worn-out tablecloth, a curtain, a flea market find— being transformed. And after odd scraps of material, one realizes that there's no excuse for ever wearing dull clothing.

plain denim skirt, a tattered everything runs the risk of seeing what can be done with

Most charming and old-fashioned are a blouse and skirt collaged with lace. It all started with a simple button-front blouse made from an oriental silk brocade tablecloth worn sheer with years of use. Laces from collars, yokes, handkerchiefs, and children's clothes were appliquéd onto the blouse until only a glimpse of the original fabric remained. A long skirt made from the same table-cloth was also appliquéd, but much more sparsely, with lace and square patches of dainty cotton prints. Whenever the fragile base fabric of the skirt and blouse starts to wear through, an appliqué of fabric or lace is used to cover the bare spot.

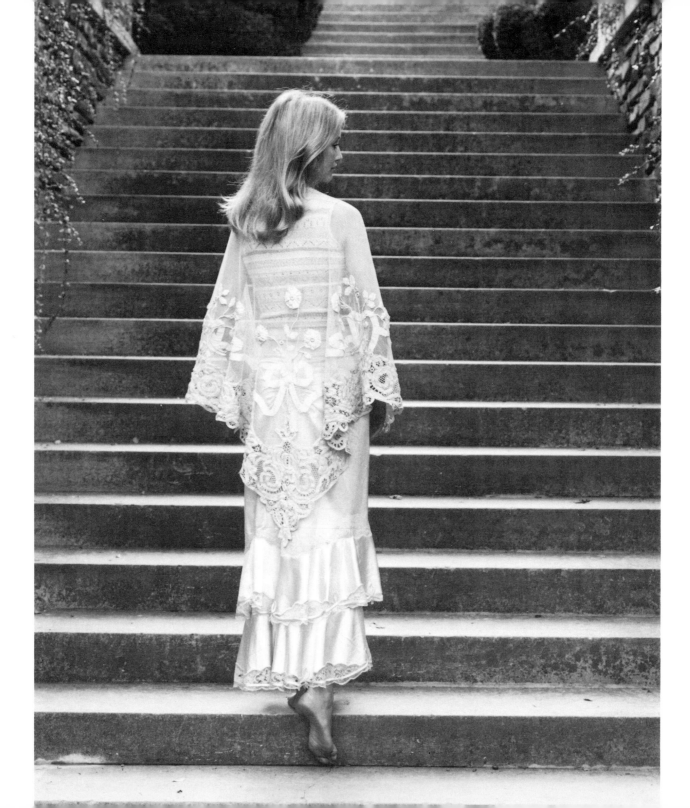

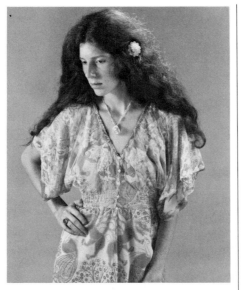

The transformation can be as simple as the shawl that was made by cutting an old lace curtain in half diagonally. The long cut edge was bound with a thin lace strip, the somewhat ragged appliquéd bow was deftly mended, and the result was a romantic lace shawl.

The voluminous flared skirt of a 1950s silk chiffon dress provided the fabric for this recycled dress. The kimono-style bodice, stitched to a wide gathered band, is overlaid with a piece of old lace cut from a kimono pattern. Individual lace flowers are appliquéd all along the front and neck, and crochet-covered buttons add a finishing touch.

There are certain pieces of clothing one buys almost out of a sense of duty—articles that no wardrobe should be without—and then realizes that they are deadly dull. The basic black dress is a classic example—a good solid adaptable item, but hardly a unique or personal statement. One solution to the basic black dress is to add a border along the bottom of a solid color or a contrasting print, in cotton or silk. A bias strip in another fabric can be used to bind the neckline: sewn by machine around the inside, folded over, and finished on the outside by hand with a favorite stitch. A lace or crochet collar could be attached around the neckline and, in addition, a slit could be cut in the front

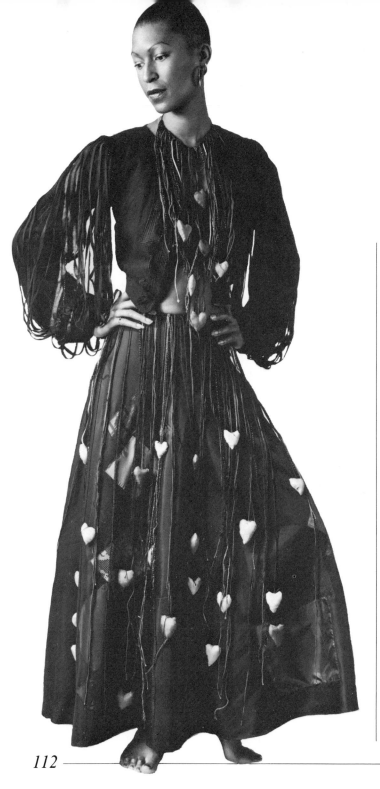

to give an opportunity for adding buttons and loops or silk ties. Buttons and loops could also be stitched onto the shoulder seams. Square patches in a variety of fabrics could be scattered from hem to bodice to create an abstract composition and give an offbeat effect. New sleeves could be made of patchwork or pleats; silk, velveteen, or cotton; prints or solids. Cuffs could be added of any size and any material, incorporating pleats, appliqués, embroideries, or laces, with buttons or ties to be used to close them. The result will be far livelier, and much more fun to wear.

Far more complicated is São's transformation of a black silk skirt and wool jacket, both from the 1920s. First she appliquéd silk patches to the skirt and attached cords, yarn, and shredded silk from the shoulder to the cuff of the jacket—this to recreate the cobwebby look of the original worn lining. Then she constructed a tie-on necklace and belt with similar cords and strips, from which dangle dozens of stuffed silk hearts in dark soft colors. The result is fanciful and bizarre, personal and unique.

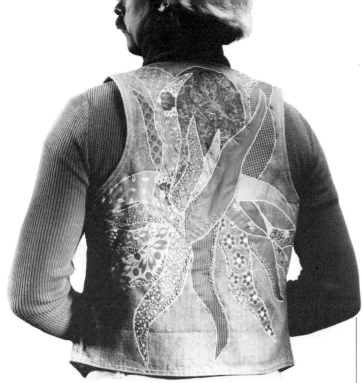

In recent years the basic black has become basic blue—blue jeans have become the national costume, with no sign of fading. Denim is the new neutral that goes with everything. There is something about it that brings out the artist in everyone. Sturdy and inexpensive, it can be adorned in myriad ways and makes wonderfully imaginative presents for friends, family, and self. A man's denim vest is machine appliquéd with an octopuslike creature stretching across the back and wriggling around the sides to the front. Denim handbags can also be embroidered; buttons, beads, and small stuffed hearts, stars, birds, feathers, tassels, and petit point can be attached for decoration; or multiple pockets can be appliquéd to make the bag more useful for traveling.

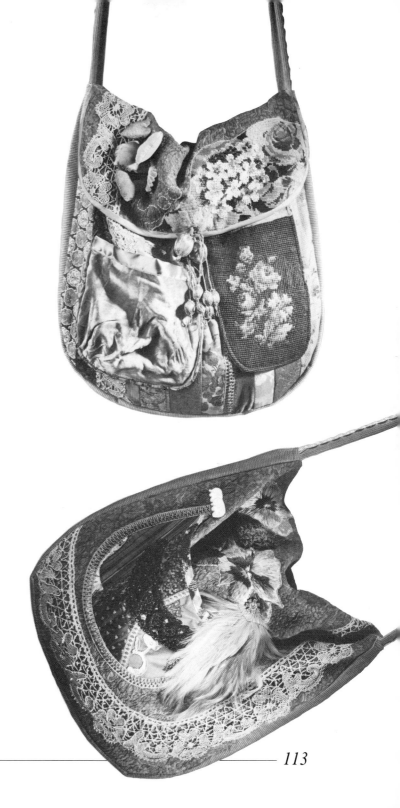

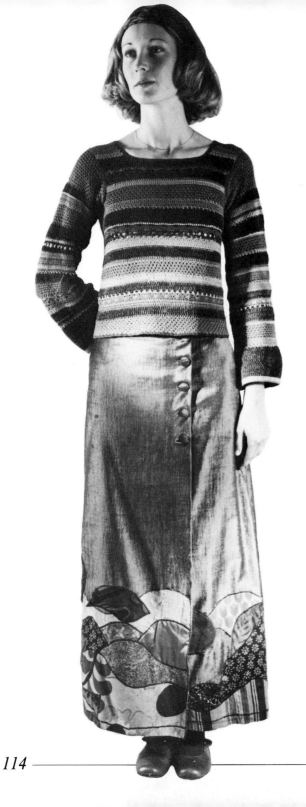

Wandering through the Paris flea market, São discovered a simple red velvet skirt, itself recycled from an old theater curtain. The skirt was well worth the few francs the seller was asking. First São removed the heavy velvet waistband, adding a lining to ease wear and to finish off the waistline. Both lining and velvet were sewn together, then folded; a line of machine-stitching around the edge keeps the lining from showing in the front. The original broken buttons were replaced with five new ones covered with velvet left over from the waistband. A fanciful landscape, made mostly of printed cottons, velours, and silks, was sewn on by machine, using a buttonhole stitch all the way around. Similarly, a woman's denim skirt and a man's velvet jacket, which were stained in front, were not only salvaged but also enlivened with the addition of colorful appliqués. A newly created vest and bow tie complement the man's recycled jacket; a long "string" of lace is an interesting alternative to a long scarf.

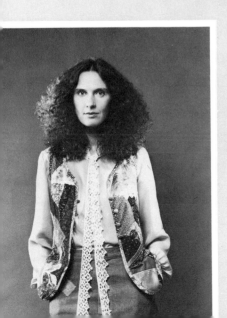
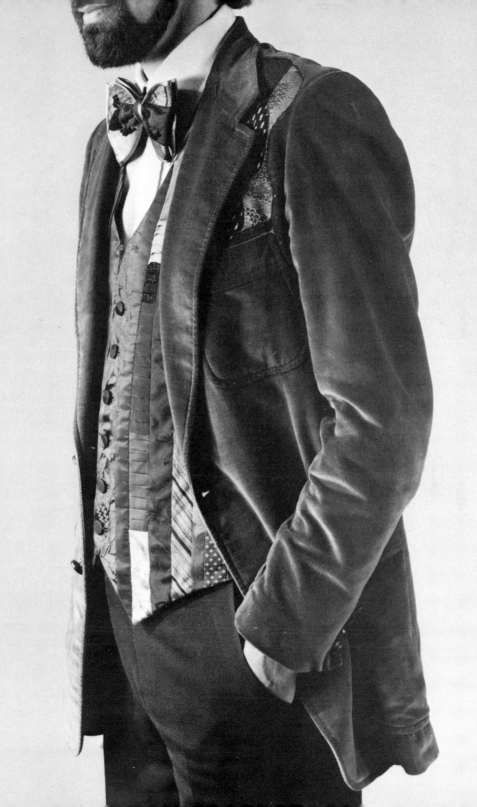

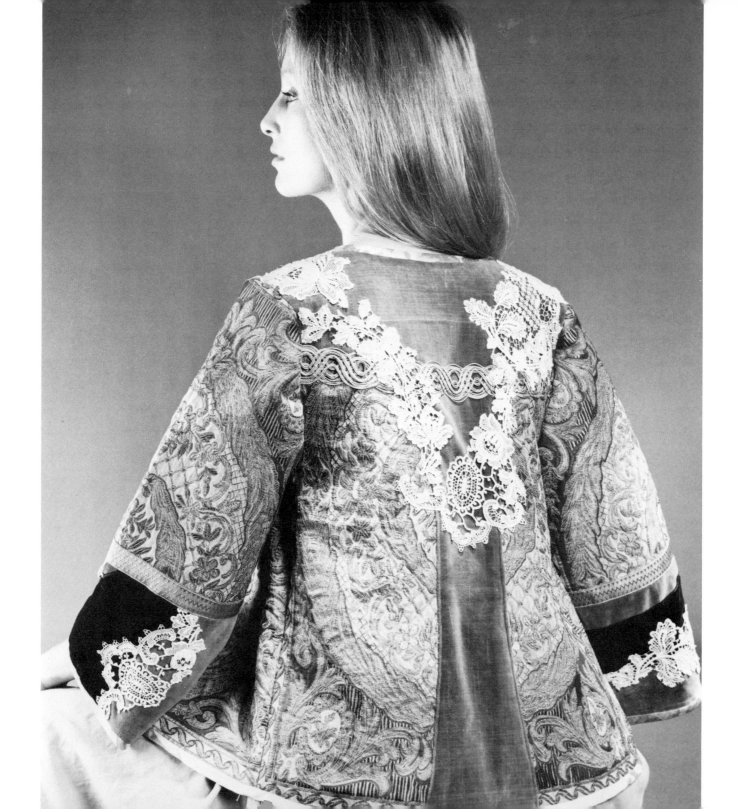

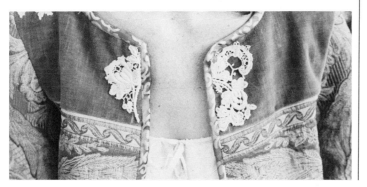

A grandmother's brocade piano shawl and a large tabletop doily were the inspiration for a sumptuous jacket. Carnelian and brown velvet (taken in part from the shawl's lining) were added to the jacket to soften and ease the heaviness of the brocade; wide borders of the same velvets were attached to the sleeves, continuing the design.

Flower motifs were carefully cut from an old lace doily to provide a touch of luxury, and a contemporary printed silk border cut on the bias finishes all the edges with a lively accent and holds the jacket and lining together.

Laces for these and other projects—a photo album, for instance—can be unearthed from dusty heaps in the corners of antique shops. Oftentimes stained and torn, they must be reconstructed before they can be used. São frequently dyes the ones that are badly discolored, though this is always a risk since some are so fragile they simply disintegrate.

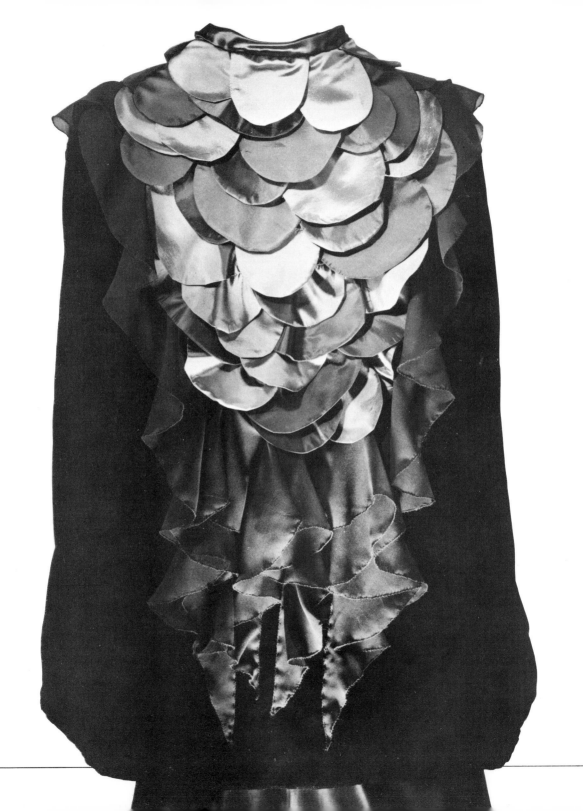

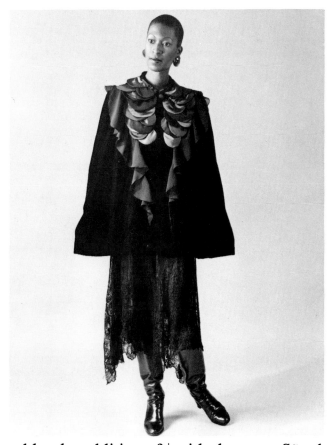

Nothing is safe from São's inventive eye. A short velvet cape from the 1920s was recreated by the addition of a yoke of silk taffeta "scales." Each scale is sewn separately from two pieces of fabric (stitched together then turned inside out to hide the seams) and appliquéd by hand onto the cape. Ruffles of silk chiffon cut from a circle were hemmed by hand with silk thread in a flat basting stitch, then appliquéd to the cape along the sides and at the bottom in the back, using the same stitch. To go with the cape, São detached a piece of old lace from a dress, lined it with silk chiffon to keep its transparency, and wore this either by itself or over another long silk skirt. It ties around the waist with a thin crocheted cotton cord that is woven through the lace.

Similarly, an old black coat is currently enjoying a comeback with silk taffeta scales and

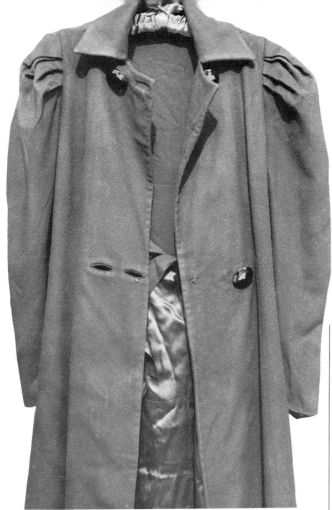

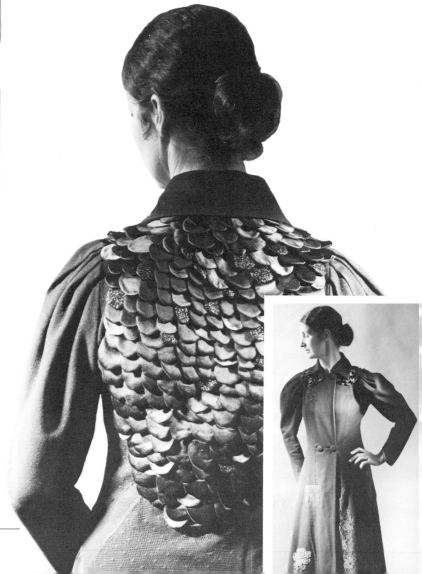

appliqués of different materials and designs. A plain white vest now vibrates with the addition of colorful stitches and images.

There is something particularly pleasing about transforming the old into the new, and the more imagination one uses, the more satisfying the results are apt to be. For São, the initial inspiration of what she can do to recreate a piece of clothing often comes from the fabric itself, whether straight off the bolt or rediscovered in some forgotten corner. As she tells it:

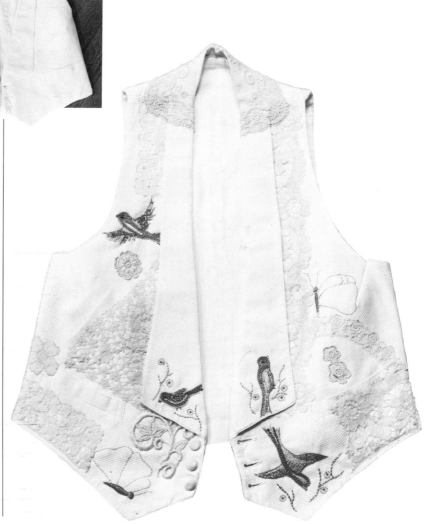

"I once had several pairs of corduroy pants and a skirt that, for some reason, I stopped wearing. But I never stopped liking corduroy, so I cut them up in squares, added remnants from other clothes, and made a pillow. When I realized how beautiful the colors were once they were joined together in a smaller pattern, I was inspired to highlight the seams with a few simple embroidery and quilting stitches. That pillow in turn became the starting point for a series of vests made of squares sewn together, then cut following a simple pattern with straight lines. Making a pillow is very easy—it takes four straight seams. A vest is equally simple: it can have two side seams and two shoulder seams or, even more simply, just the shoulder seams. Later I made a tablecloth and an A-line skirt and eventually a wall hanging.

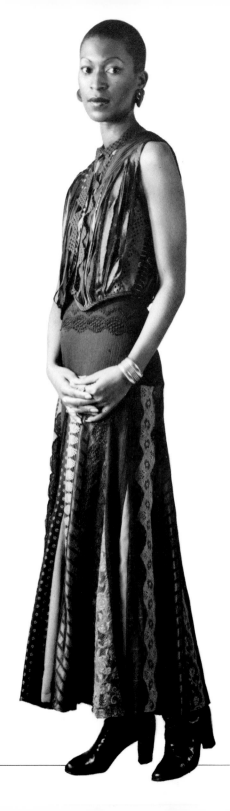

"Once I had made my first experiment I felt more courageous about carrying on with other fabrics. When I decided to re-use my summer-type fabrics (cottons, silks, linens) from clothes in the closet, left-over fabrics, and the new fabrics I can never resist buying, I made a new pillow. This time I again decided on a simple design. I cut every fabric that I chose for the project into thin strips of different widths. I sewed them together on the machine, incorporating pieces of lace among the seams to give it an old look. But when I finished my pillow I did not stop. I made a skirt of different panels in these materials using the same A-line pattern as before. I also used the same vest pattern as before, but the effect was different because the design I recreated with the fabrics gave the composition a different look: here I used torn pieces of fabric over the appliquéd strips and lace.

"I used the same idea of strips of fabric sewn together to solve the problem of how to treat my windows. I covered the frames of window shutters with panels made of the many strips. The strips of fabric were appliquéd on gauze and attached to canvas stretchers that had been hinged together.

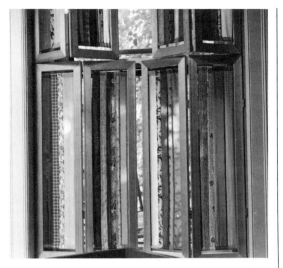

Break the rules. Forget about fashion. Try odd combinations of colors and patterns. Look at things not as they are, but as they might be. Remember Scarlett and her green velvet curtains in *Gone with the Wind*? A rose is a rose is a rose, but a tablecloth can be a skirt or a blouse or an appliquéd flower. Improvise. Invent. Imagine.

"My precious Empire couch, purchased for a small sum at a local antique shop, needed reupholstering. Choosing a plum-colored corduroy for a base, I machine appliquéd strips of old and new fabrics directly onto the corduroy, allowing it to show through every so often. Each strip was folded over before the next one was applied, so that the seams were all hidden; the edge of the last strip was folded under and I used my favorite hand stitch to finish off the raw edge."

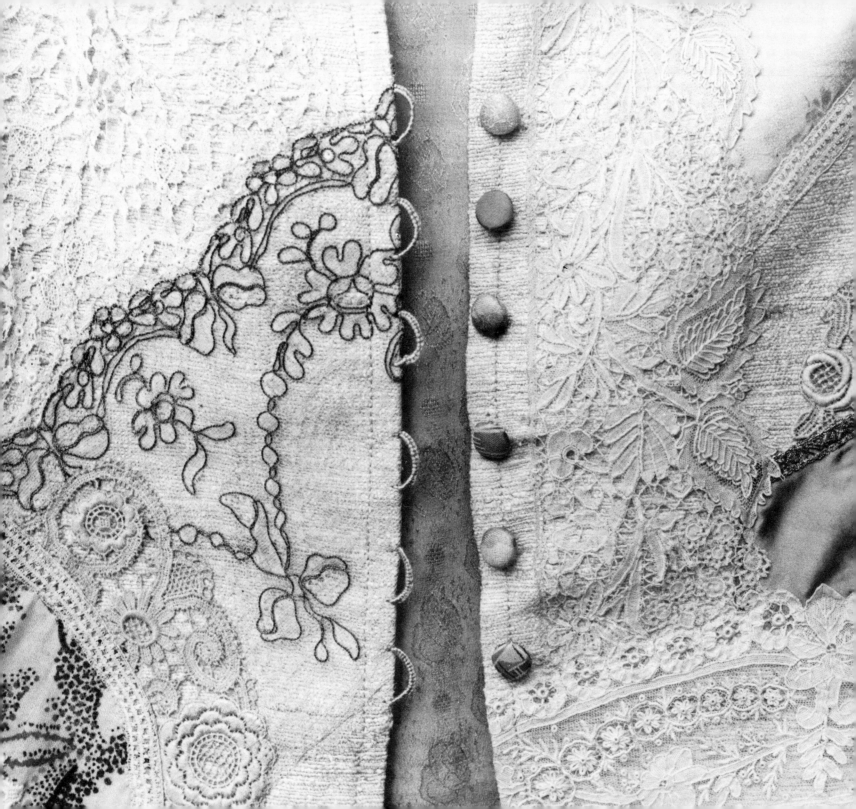

8. FINISHING TOUCHES

Once the more difficult work has been done—the pattern has been cut, the seams have been sewn, the hems have been turned—the fun can begin. Choosing the finishing touches for a garment is as important as it is pleasurable, for it is just those touches, whether an eye-catching clasp or an embroidered edge, that can help transform something from looking home-made to hand-made. These elements should not, of course, overwhelm the piece. Keep in mind the total effect and choose accordingly, with an eye toward harmony and balance.

For example, six buttons for a collage vest could be covered in six different fabrics from the collage, providing a bit of liveliness without distracting from the overall unity. Button loops can also be made of the same collage fabric or crocheted from cord in a matching or contrasting color. Old buttons of varied, but related, colors or patterns can also be effective—a row of creatively mismatched buttons adds an intriguing visual complexity to even the simplest piece.

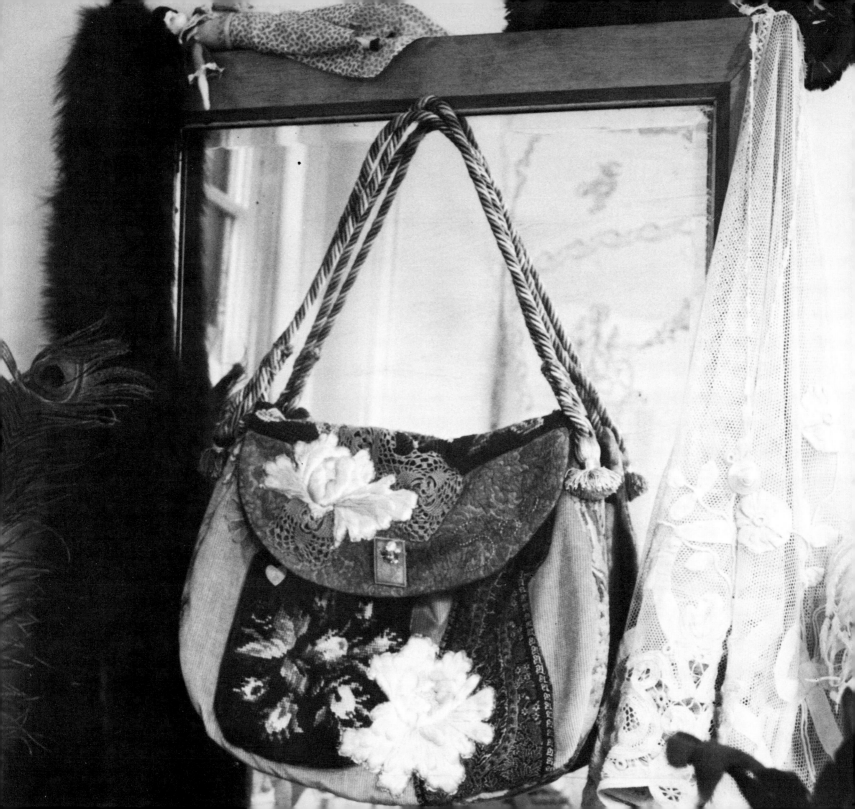

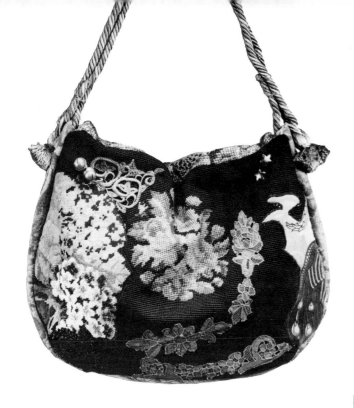

Interesting buttons turn up in the oddest places—the bottom of a long-forgotten sewing box, a cluttered corner of grandmother's attic, a half-hidden basket in a favorite antique store, or on the cuffs of a rummage-sale discard. Also to be discovered in such environs are buckles and tassles and old-fashioned doodads that can be put to imaginative new uses. And while looking around, keep an eye out for materials that could be used for cuffs and collars: furs, lace, feathers, silk, old beadwork.

São's work demonstrates how beautiful linings can be—whether printed or plain, knitted or silk, they are considered as carefully as the outside surfaces. Sometimes a bit of lace or ribbon is tucked away on the inside as well—an unexpected delight to surprise the wearer. A simple embroidered edge, or one as compli-

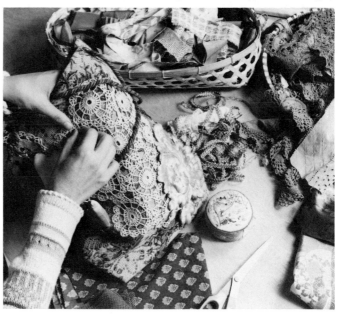

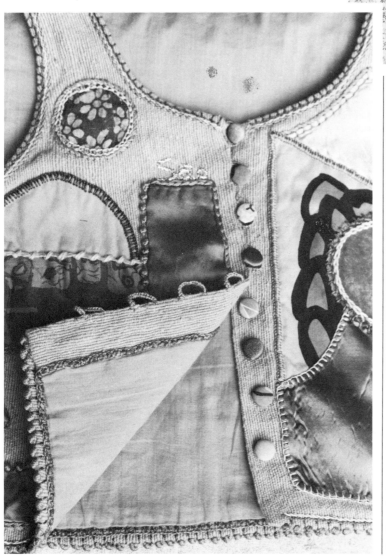

cated as the multi-stitch version on the vest (detail, left), can also supply a finishing touch. A hem can be more than just the end of the garment.

Pockets of all shapes and sizes can also be added to garments. A row of pockets in various patterns and colors can run down a pants leg or along the sleeve of a favorite but fraying shirt. Quirky pockets knit or crocheted of cotton or wool can be stitched to a denim skirt or to a long wool dress and embroidery can be added for still another layer of decorative detail. An elegant pleated pocket—edged, perhaps, with a line of metallic thread—could be stitched to a very simple silk blouse. Or, still more simple, a square cut from an old lace doily can provide a pocket that might hold a dainty lace hanky or serve as the background for a treasured brooch.

The trick, it seems, is to think again—even after a piece looks finished, take another look. There may be one last little touch that—without looking fussy or overworked—will make the piece look exactly right.

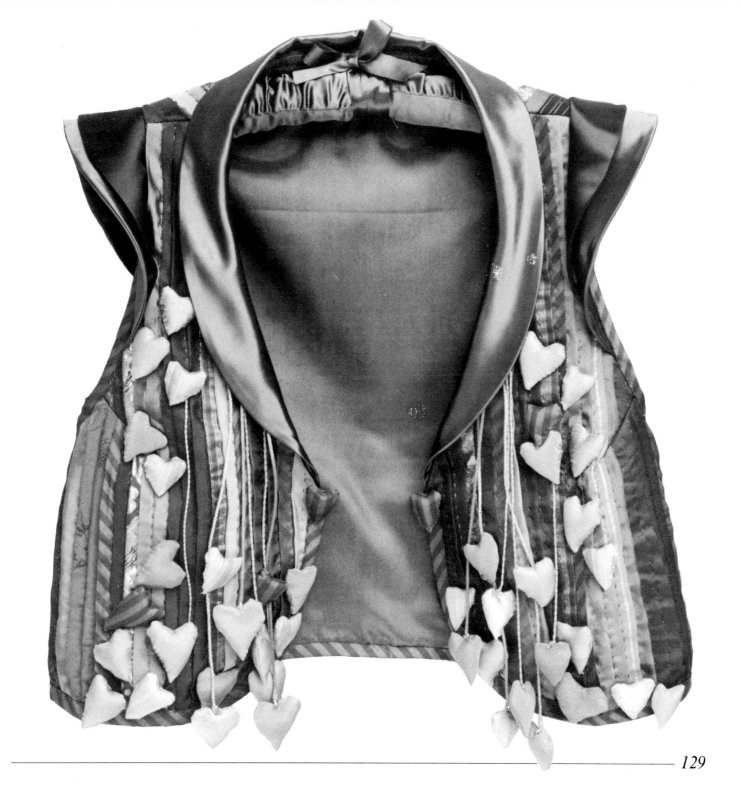

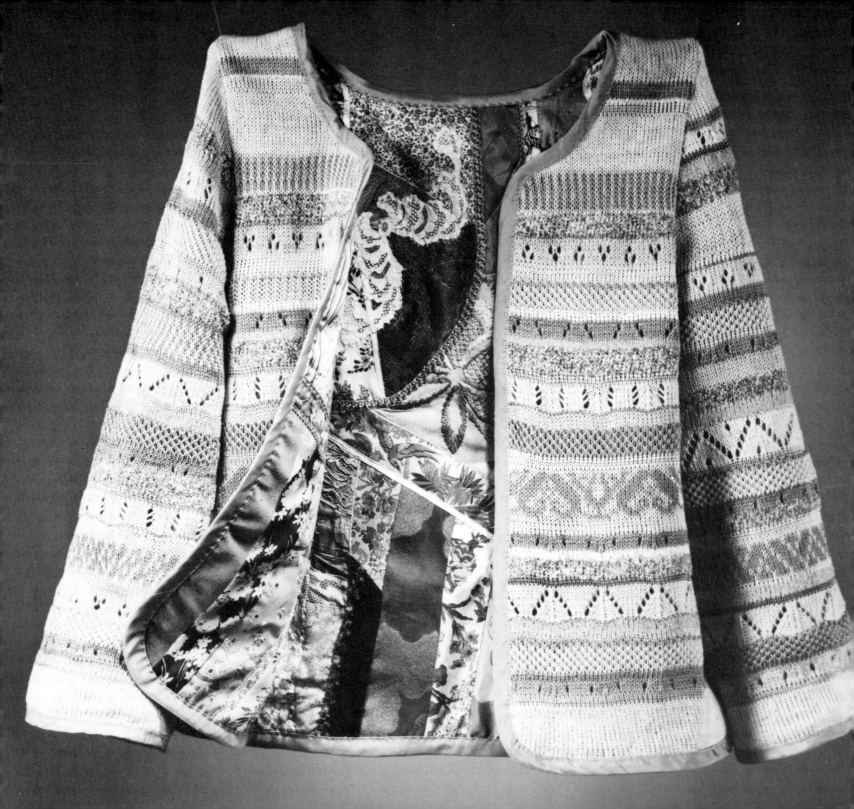

9. FLEXIBLE CLOTHING

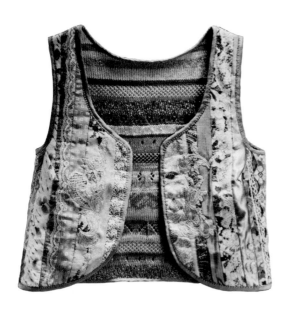
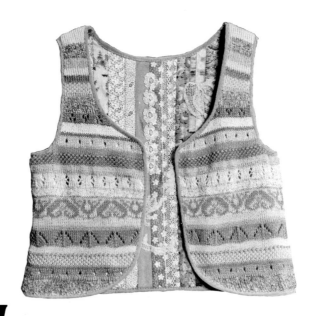

Wearables can really get *worn:* to parties, plays, and museum openings, as well as to picnics and *tête à têtes*. They are fun to wear—all that detail, all those colors and shapes and textures keep them from ever becoming boring. Another reason is that there are so many ways they can be worn, for they are designed to be as flexible as possible. More often than not the jackets and vests seen here are reversible: horizontal knit stripes may reverse to a free-form collage (see also plates 6, 18, and 19); a patchwork of velvet and silk prints may reveal a sparsely appliquéd field of black velvet on the other side. By thus literally becoming two pieces in one, each piece can be worn with a variety of garments and accessories, from blue jeans to a knit skirt to a long silk dress—depending on the mood and the moment.

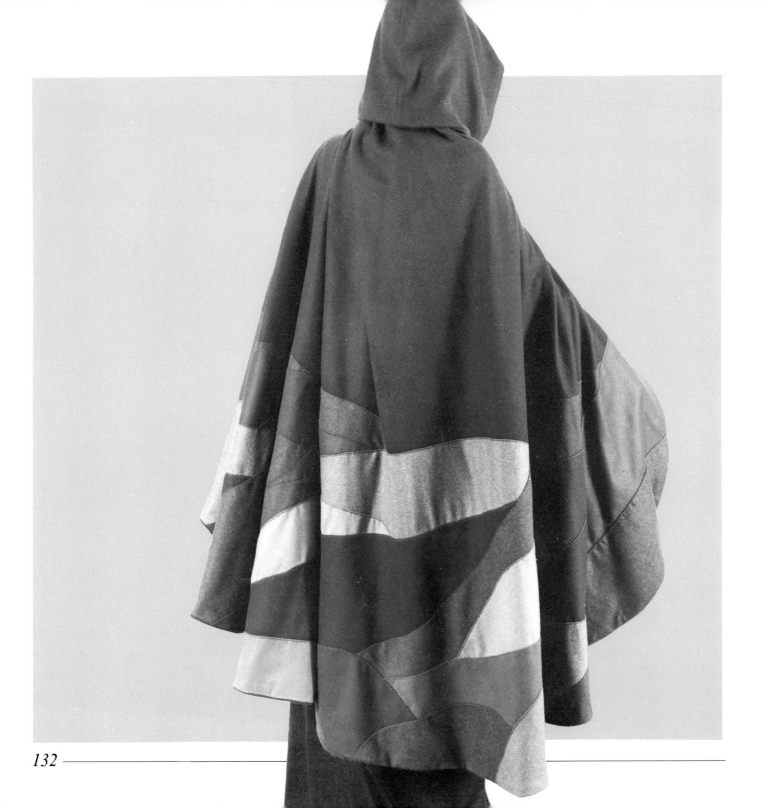

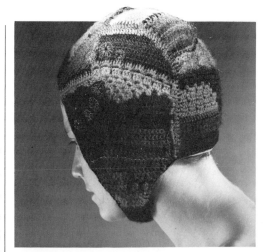

Different moods can be expressed by different sides of the same piece. The long wool cape, for example, can be worn with its plain side out—a simple, serviceable blue cape, good for keeping warm and hiding in a crowd. But on days when anonymity loses its appeal, the cape reverses to reveal horizons of purple, sage, and sandstone, a shadowy landscape.

A reversible patchwork cap can be worn on either side, depending on the wearer's inclination. This is one of the rare instances when São followed a pattern for her crochet: the general shape of each section was modeled after the fabric patchwork on the other side. Within each section, however, the shapes are free form, and the stitches are as varied as the colors. Highlights embroidered in silver and gold add a final note of complexity.

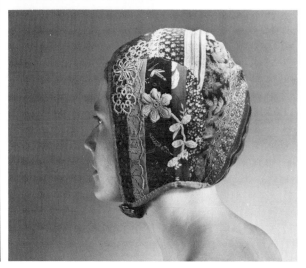

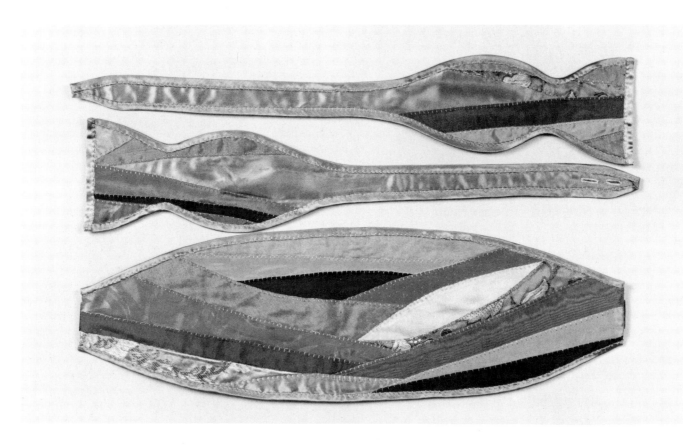

Neither side of the silk and satin cummerbund and bow tie could ever be accused of anonymity—with their collages of brocades and glittering embroidery, both sides strike a blow against the black and white tedium of traditional tuxedos.

A wrap-around skirt can also be reversible, flipping in the wind to reveal a gleam of contrasting color on the other side. It's best to choose fabric of similar weight and texture so that the skirt will hang gracefully, but there are no limits on the possible combinations of colors

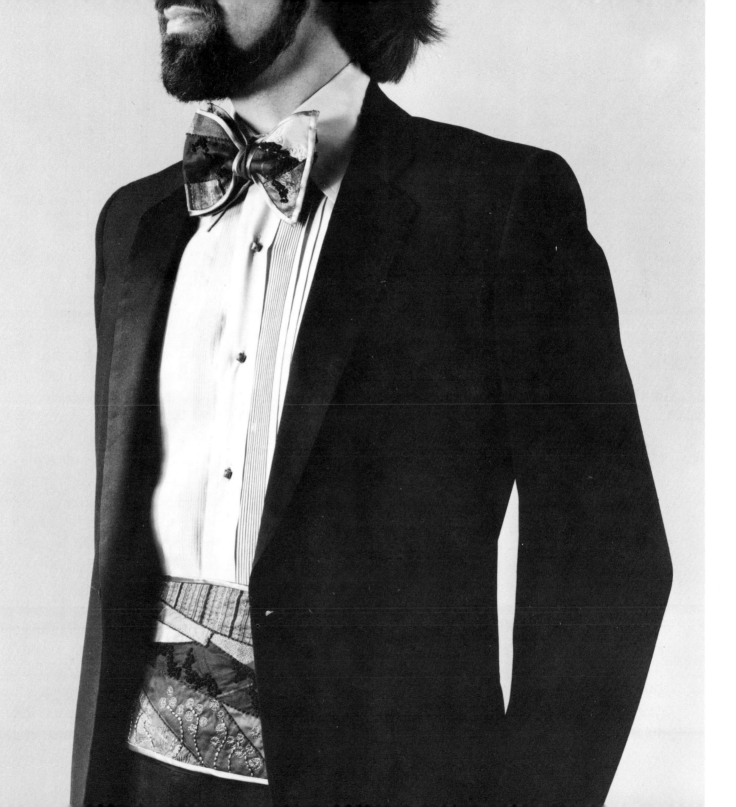

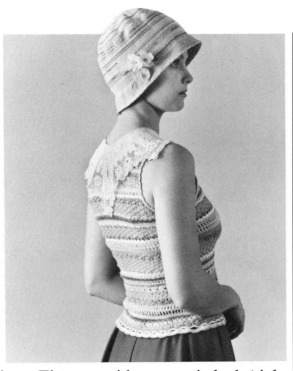

and prints. The two sides are stitched (right sides together) around all edges but the waist, then turned inside out. Sew on a waistband with long ties—and possibly big patch pockets of identical size and shape but different fabric—and the skirt is ready for wearing. Equally easy to make would be a large triangular or semi-circular shawl. One side could be a translucent chiffon, the other—perhaps cut a few inches larger—an antique lace. Stitch the two together at the top, hand-roll the hems, and the result is a romantic evening shawl, quickly made and long cherished.

Accessories of various kinds, from the simplest to the most complex, can increase the flexibility of clothing. A lace collar—either a dainty old-fashioned one found in an antique store or one hand-crocheted in a contemporary style—can be basted to a simple shirt and replaced or removed when it no longer pleases. Similarly, a piece of lace could be temporarily tacked onto the waist of a skirt. Or, a length of antique lace could simply be wrapped over a long skirt or worn alone over black tights and boots.

Perhaps it is their timelessness that makes the wearables most flexible—they relate to no fashion, they are not in style one season and out the next. Designed as beautiful objects rather than simply as fashionable garments, they are expressions of a unique personal aesthetic.

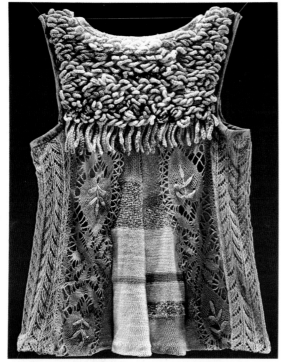

15

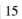

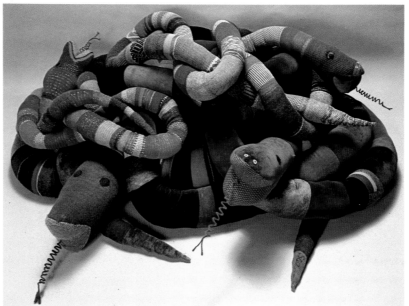

16

17

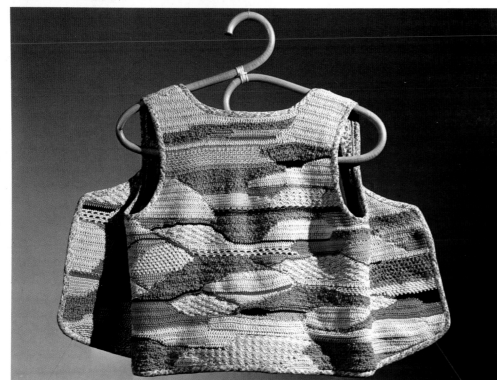

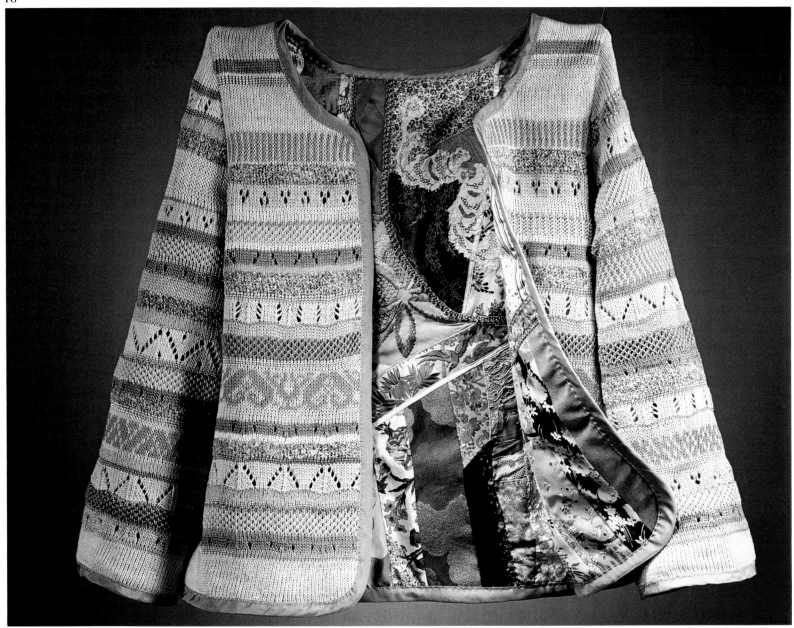

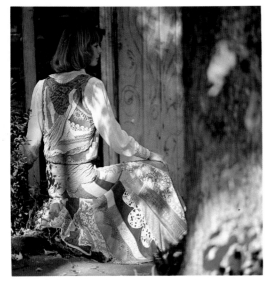

21

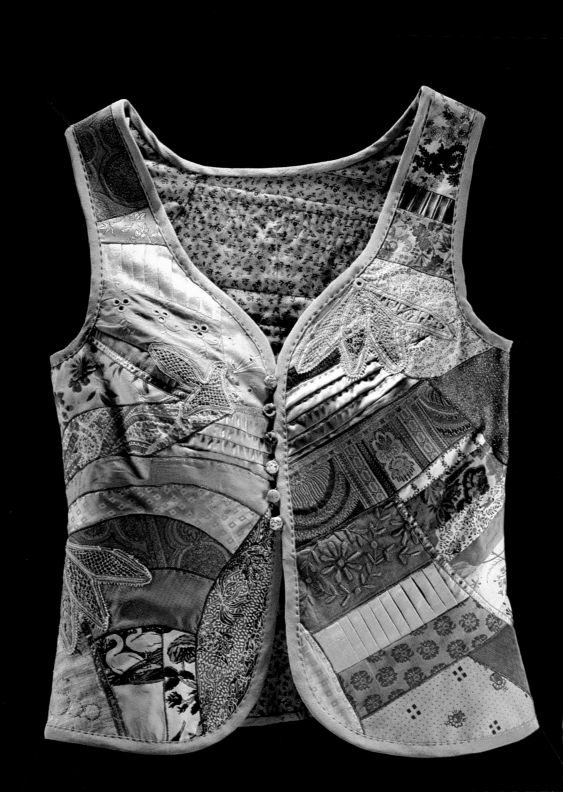

22

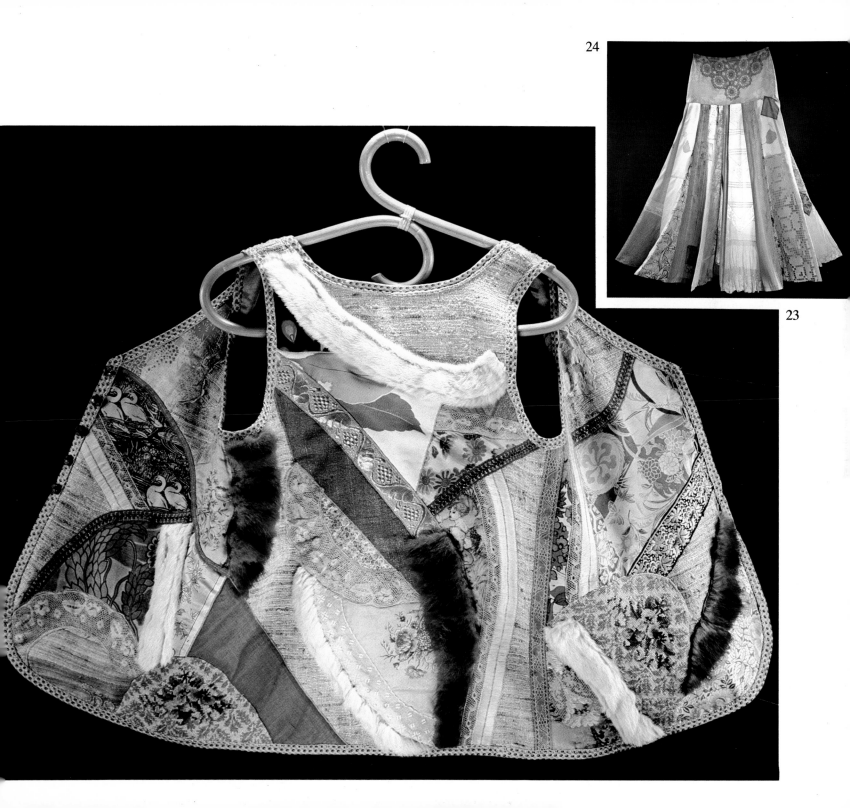

24

23

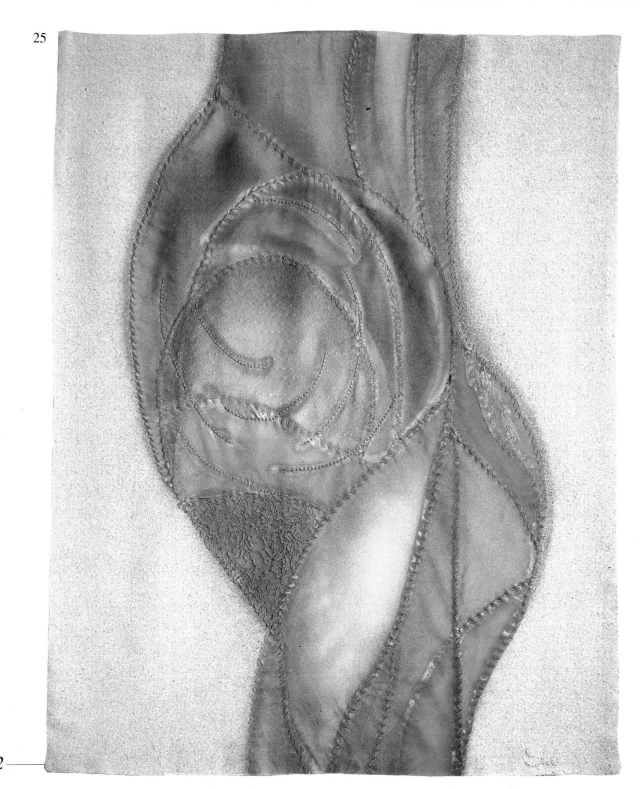

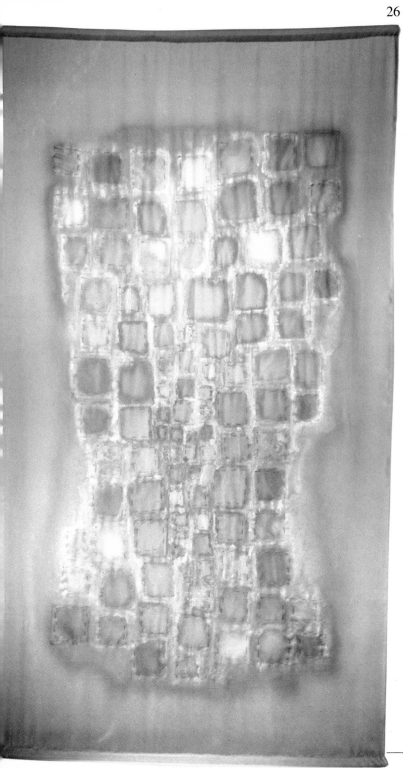

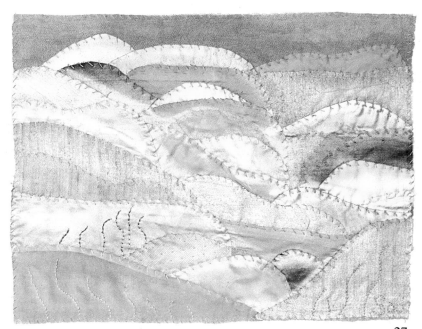

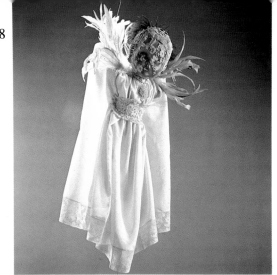

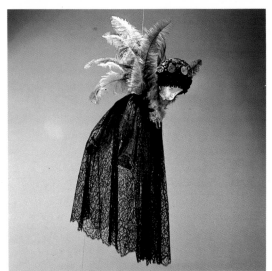

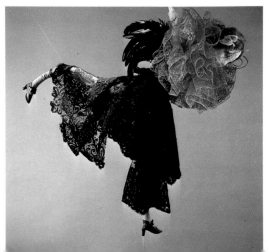

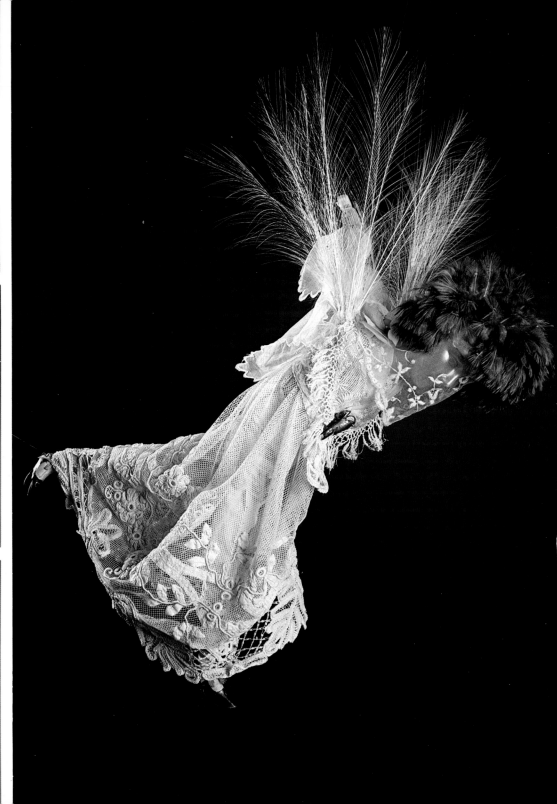

10. ART AND WEARABLE ART

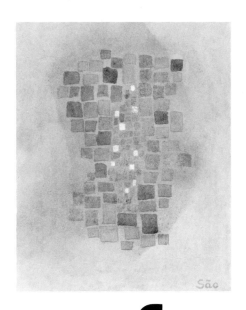

Certain threads run through all of São's art: love of nature, love of beauty. Sometimes subtle, sometimes exuberant, her wall hangings, dolls, and wearable art share an almost startling opulence of texture and color.

In the abstract collage, *Untitled* (watercolor shown here; see also plate 26), the squares of gemlike colors, suspended between two layers of translucent silk gauze and overpainted with metallic highlights, glow with the light like a stained glass window. Having incorporated paint into her hangings for a couple of years, São has now learned how to "paint" with fabric alone. By leaving edges frayed and unfinished, by layering fabrics of different textures, she produces painterly effects that flow across the surface.

Watercolor for Untitled. *80 × 43 in. Silk and lamé basted with silk thread between two layers of gauze; overpainted with metallic acrylic.*

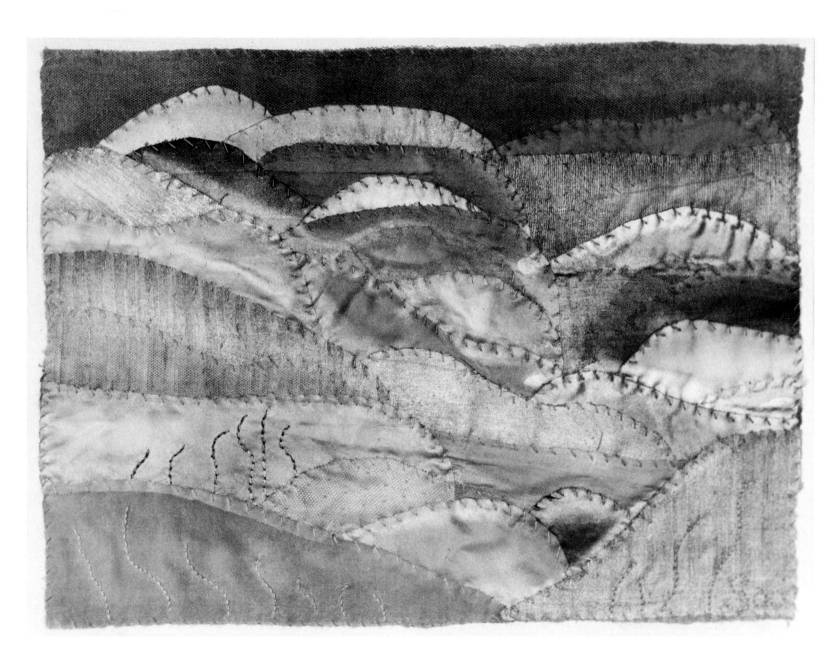

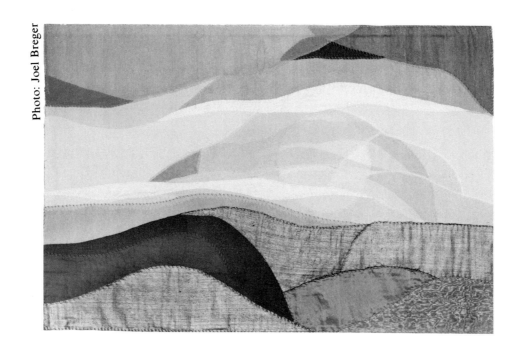

Photo: Joel Breger

Left: Nature Series I. *18 × 24 in. Silk, lace, and cotton hand appliquéd on linen; brushed and air-brushed with metallic acrylic.*
Above: Nature Series III. *54 × 83 in. Silk, linen, and gauze hand appliquéd on hand-woven cotton.*

This evolution can be seen in the two landscape hangings—numbers one and three in the Nature Series (see also plate 27)—the earlier with its crisp lines and airbrushed accents, the latter with its smooth transitions achieved entirely with fabric.

There has been another, less definite evolution in her work: that from representational

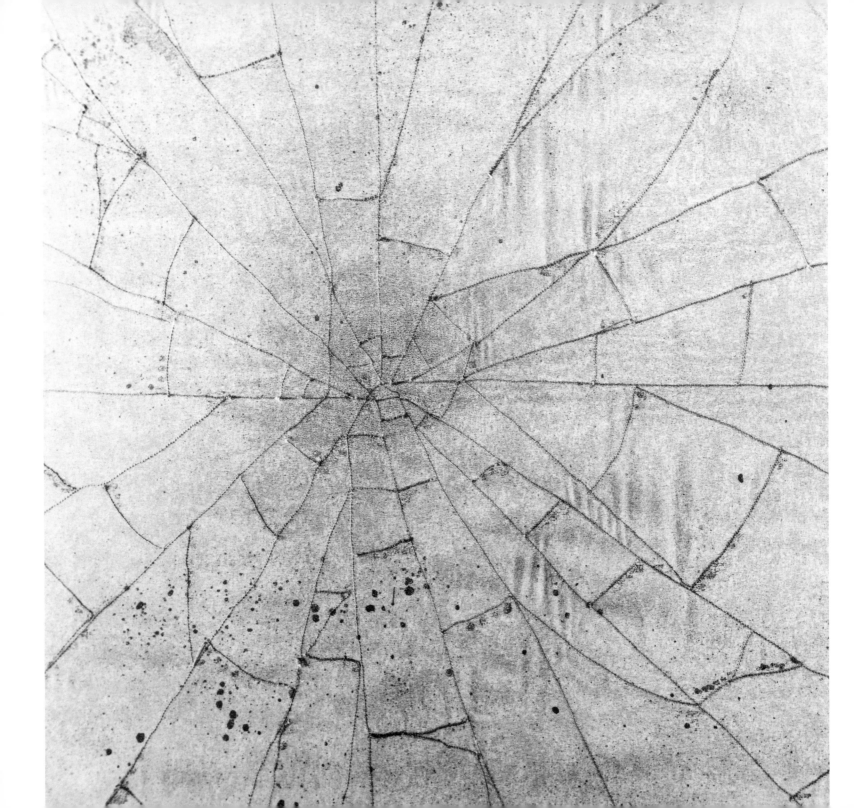

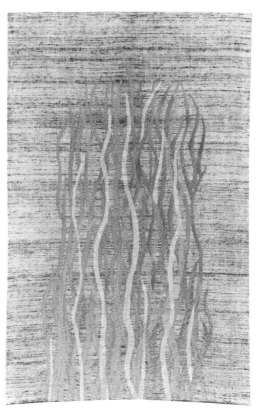

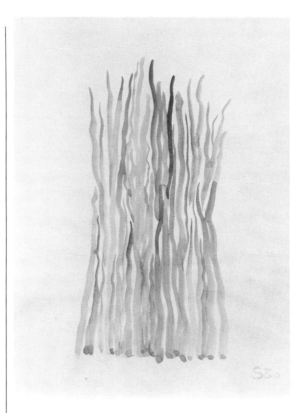

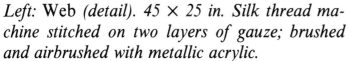

Left: Web *(detail). 45 × 25 in. Silk thread machine stitched on two layers of gauze; brushed and airbrushed with metallic acrylic.*
Above left: Sea Anemone. *76 × 48 in. Silk, net, and chiffon hand appliquéd on hand-woven raw silk. Right: Watercolor for* Sea Anemone.

to abstract imagery. São has always been intensely responsive to nature, and many of her hangings have taken their subjects directly from that source. The shimmering *Web,* for example, and the gracefully undulating *Sea Anemone,* represent quite clearly the subjects that inspired them.

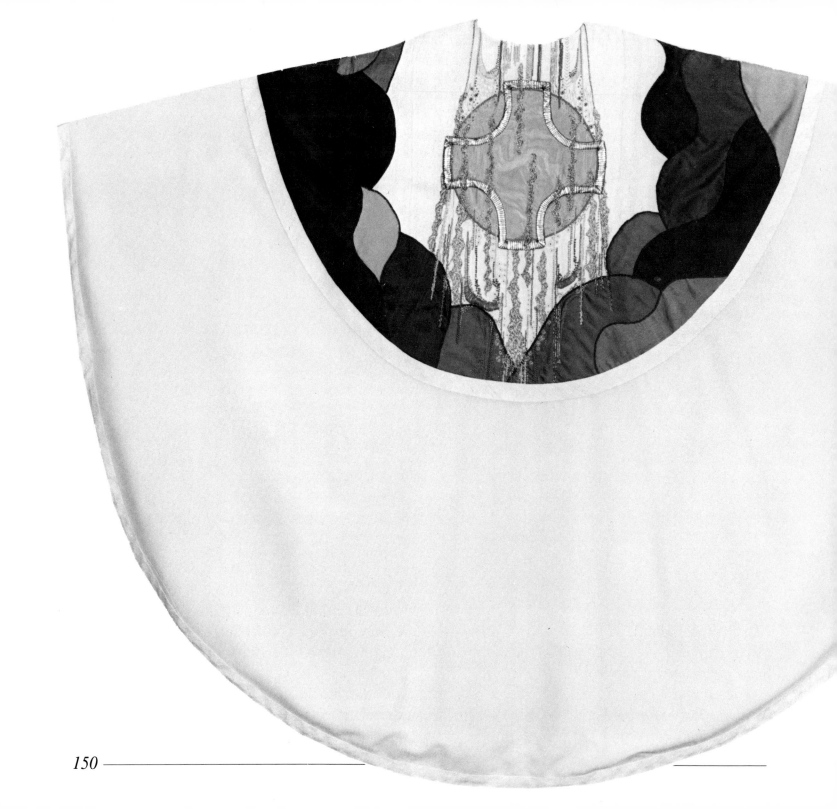

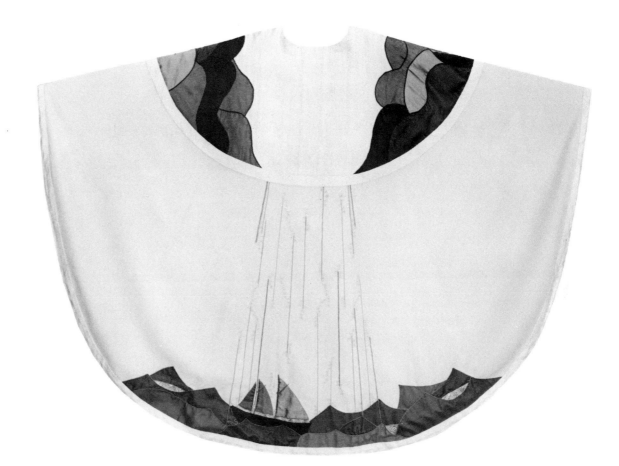

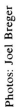

In the vestments commissioned by the Washington National Cathedral, the nature imagery has become more symbolic, illustrating the theme of the four elements with almost a pagan splendor. On the front of the chasuble the sea and sails are engulfed by a shower of silvery air; on the back the golden sun and flames burn with vivid radiance. The chasuble is made of Irish wool, with a yoke of hand-woven raw silk, appliquéd by hand with a buttonhole stitch, and with embroidery in silk and gold threads in a variety of stitches.

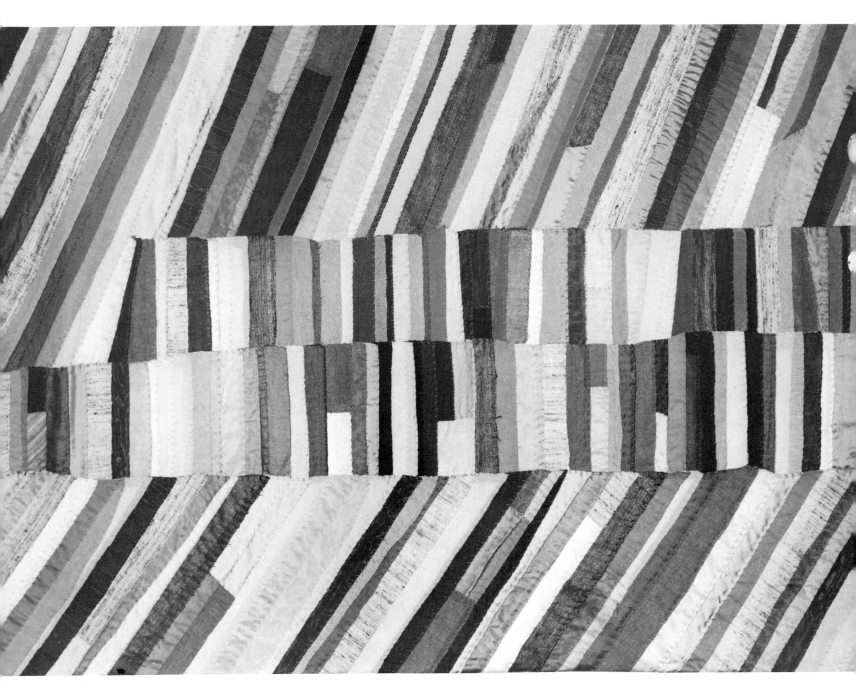

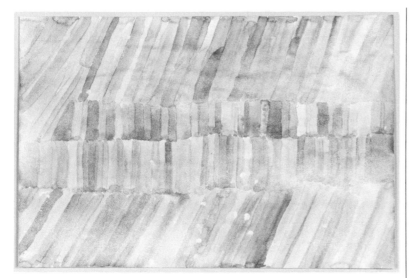

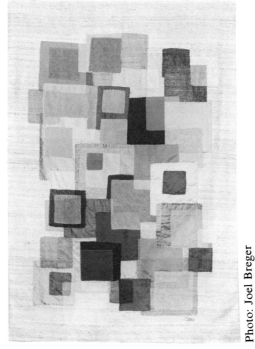

Photo: Joel Breger

While São continues to produce works that reveal immediate inspiration from nature, the balance has shifted toward purer abstraction. In the *Striped Collage*, the structure still suggests a landscape, perhaps as glimpsed from an aerial perspective, but it is essentially an abstract composition. In the *Square Collage* the overlapping, intertwining shapes are clearly geometric rather than organic in origin. The preparatory watercolors for these and other hangings–delicately colored and skillfully composed–are pleasing in themselves and stand as independent works.

A deep sensuality is manifested not only in São's choice of sense-gratifying materials but even more strongly in her exploration of sexual imagery. Her pregnant torsos serve as a metaphor for artistic creativity. Gleaming with gold and swirling with elegant curves, they glorify both fertility and the female body (see plate 25, *Expectancy. 43 × 34 in.*).

Opposite: Striped Collage. *58 × 80 in. A variety of natural fabrics hand appliquéd on muslin; edged in slant stitch.*
Above left: Watercolor for Striped Collage.
Above: Square Collage. *47 × 75 in. Gauze, net, and other fabrics hand appliquéd on raw silk.*

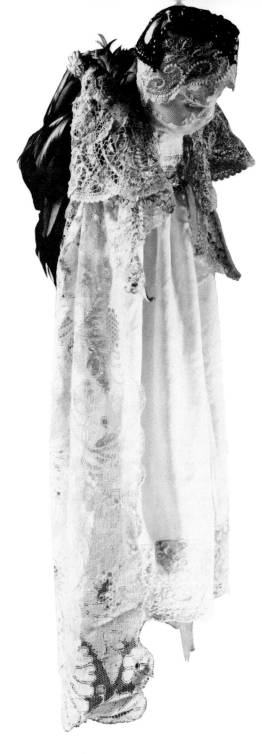

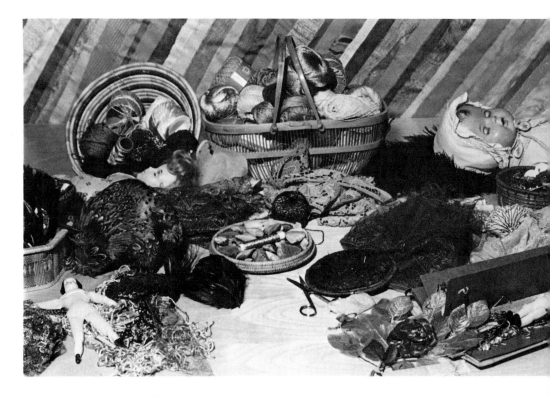

The most sensual, and the most richly allusive, of São's creations are her dolls. There is an aura of benevolence about them, an echo of girlhood innocence. Swathed in luxurious fabrics, their faces concealed by lace masks, they are mysterious and fantasy-provoking. Their feathery wings outstretched, they hover in graceful abandon. Like everything she does, the dolls enliven daily life with flashes of rare and unexpected beauty.

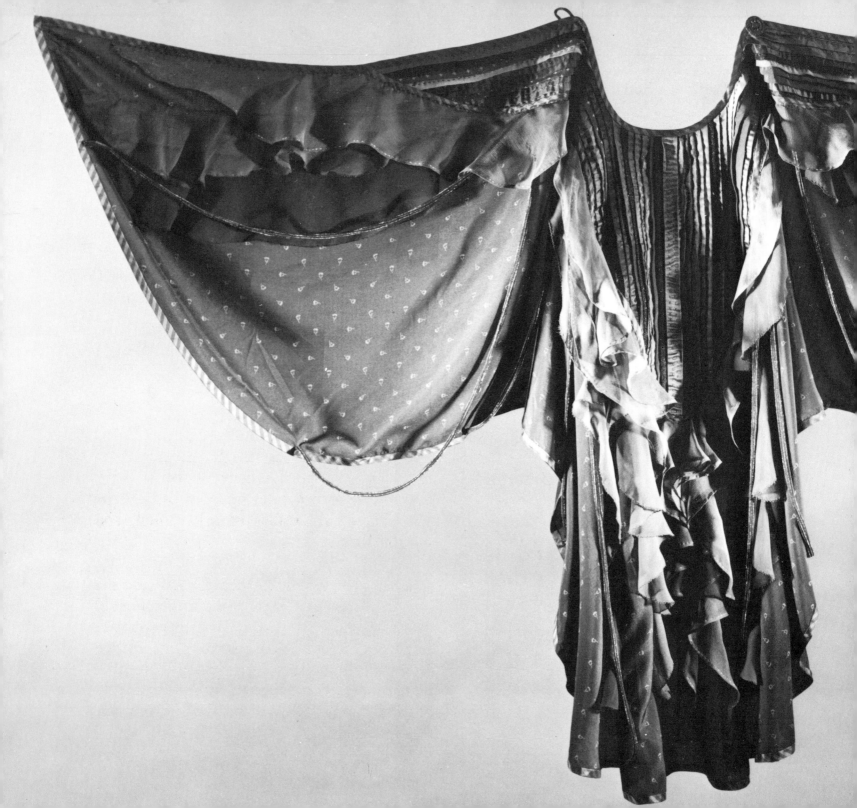

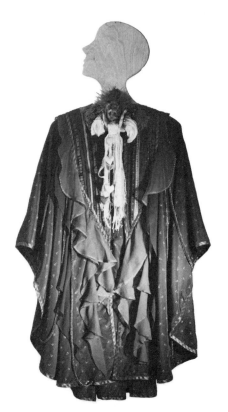

São's silk cape is a slight departure from the work that she has done in the past few years, yet it incorporates many of her favorite elements—pleats, ruffles of silk chiffon, and metallic thread.

São now has established the territory she intends to explore. Her work is continually evolving—the colors are increasingly sophisticated, the designs more intricate, the feeling more fanciful. Intensely vital, irrepressibly creative, she has produced a richly varied body of work that is always distinctly an expression of her own self.

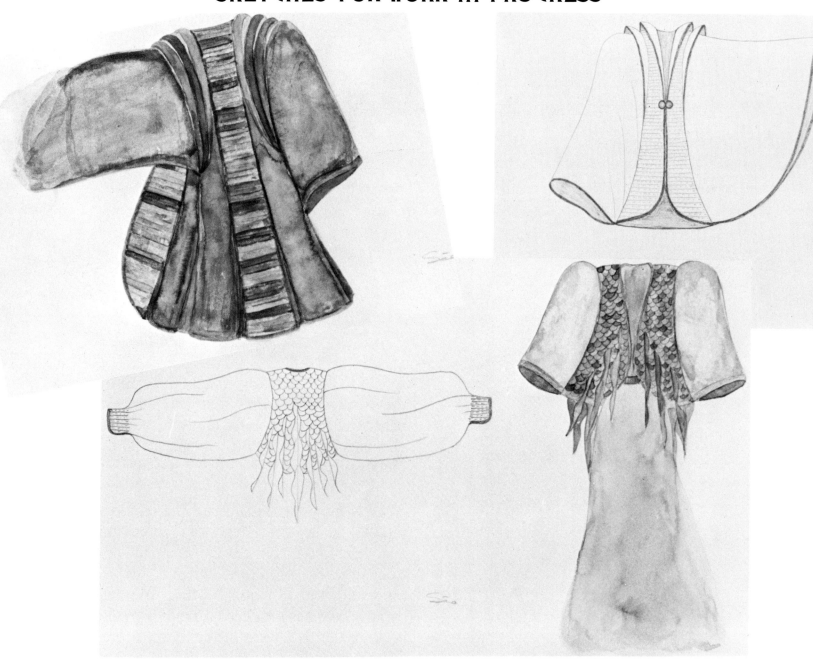

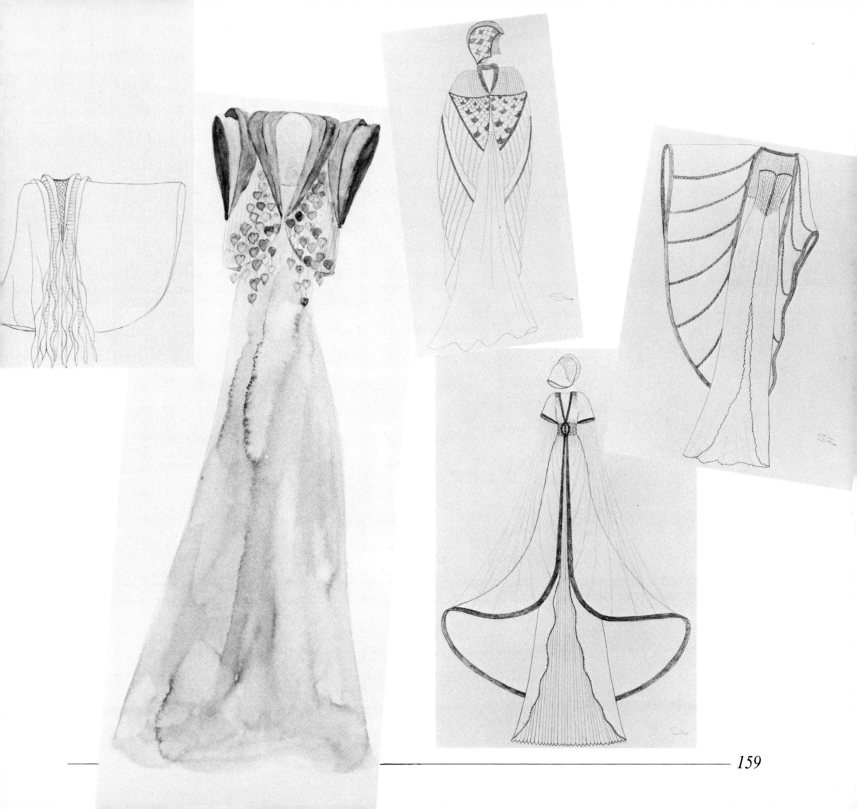

ACKNOWLEDGMENTS

I am grateful to Olga Zaferatos for editing the manuscript with care and sensitivity. I also want to thank Gael Dillon for her skill and attention in designing this book. Finally, many thanks to my friends who contributed their time to model for the photographs on the preceding pages.